THE WONDER AND COMPLEXITY
OF THE
1904 WORLD'S FAIR

THE
WONDER
AND
COMPLEXITY
OF THE
1904 WORLD'S FAIR

Edited by the Missouri Historical Society Press
Foreword by Sharon Smith

MISSOURI HISTORICAL SOCIETY PRESS
ST. LOUIS
DISTRIBUTED BY UNIVERSITY OF CHICAGO PRESS

Library of Congress Cataloging-in-Publication Data

Names: Missouri Historical Society Press, editor, issuing body.
Title: The wonder and complexity of the 1904 World's Fair / edited by the
 Missouri Historical Society Press ; foreword by Sharon Smith.
Description: St. Louis : Missouri Historical Society Press, [2024] |
 Includes bibliographical references and index. | Summary: "Six essays
 explore the wonder of the 1904 World's Fair in St. Louis, along with
 complex aspects such as prejudice, discrimination, and human zoos.
 Images and artifacts from the Missouri Historical Society Collections
 comprise a catalog at the end of the book"-- Provided by publisher.
Identifiers: LCCN 2024021231 | ISBN 9798985571646 (paperback)
Subjects: LCSH: Louisiana Purchase Exposition (1904 : Saint Louis, Mo.) |
 Exhibitions--Social aspects--Missouri--Saint Louis--History--20th
 century. | BISAC: HISTORY / United States / 20th Century | SOCIAL
 SCIENCE / Anthropology / Cultural & Social
Classification: LCC T860.B1 W66 2024 | DDC 977.8/65043--dc23/eng/20240802
LC record available at https://lccn.loc.gov/2024021231

Distributed by University of Chicago Press
Book design by Debbie Schuller
Printed and bound in the United States by Modern Litho

Cover image: "At Sunset (View across the Grand Basin at the
1904 World's Fair toward the West Restaurant Pavilion and the Ferris wheel)."
Photograph by Jessie Tarbox Beals, 1904. N20812. Back cover: Palace of Machinery,
Grand Basin, and Palace of Electricity. Unknown photographer, 1904. P0701-06.

Unless otherwise noted, all images are from the Missouri Historical Society Collections.

Contents

Foreword

By Sharon Smith

The mere mention of "exposition" or "World's Fair" conjures grandeur, wonder, majesty, and beauty. All of these words accurately describe St. Louis in 1904. St. Louis, then the nation's fourth-largest city, was near the end of a string of turn-of-the-century World's Fairs that began with Chicago in 1893. St. Louis was determined for its Fair to be record-breaking—bigger in size, longer in duration, more magnificent in every way.

And in many instances, it seems St. Louis succeeded. But do we know that for sure? Were the figures accurate, or were they inflated? Did staging a bigger World's Fair necessarily mean that it was a better one?

For as long as I can remember, I've loved going to fairs. I also loved souvenirs. Whenever I traveled, I wanted to bring back a memento of the occasion—a treasure. I wanted something that would create a physical memory of this wonderful event or place. Thirty-five years ago, I came to work at the Missouri Historical Society. After the departure of one of the curators, several staff were asked to divide her various collections. As an assistant curator, I volunteered to take the World's Fair Collection because I knew it was mostly a collection of souvenirs. The task almost seemed as though it were made for me. I didn't grow up here, so I didn't know much about the 1904 St. Louis World's Fair. But because the event had the word "Fair" in its name, I assumed it was glorious. I was also aware that MHS had plans to create a new, bigger, better World's Fair exhibit in the months ahead, and I wanted to be involved.

I have now been curating the World's Fair Collection of roughly 3,800 objects for over 25 years, and I've learned that the Fair's story involves far more than the simple beauty conveyed through ruby glass, spoons, ceramics, and photos. It's not just about the fun of the Fair. It's not just about the palaces' grandeur. There is so much nuance that isn't reflected through pretty souvenirs alone.

As the collection's curator, I have had many people ask questions about the Fair, about both its wonder and its complexity. What were people seeing and experiencing when they went to the Fair? How did it feel to stand inside those opulent palaces? What were the exhibits like? What did the Pike look, smell, and sound like? How did visitors interact with the people who had been put on display? Why was nearly all of it torn down?

There have been occasions when someone has offered to donate an item that an ancestor bought at the Fair. While I'm certainly interested in those pieces, they are almost always a souvenir piece of ruby glass, a ceramic knickknack, or a silver spoon, accompanied with the story of how the family came to have it. Some objects related to the Fair in our collection aren't as beautiful, but they're immensely important, such as the groundbreaking shovel or the wooden stake that Fair planners used to "stake their claim" to the area of Forest Park that would transform into the fairgrounds. There are also more intriguing items that have come to us, such as jars of preserved pears and tomatoes that were exhibited in the Palace of Horticulture and are now more than a century old—definitely things of wonder.

The groundbreaking ceremony for the 1904 World's Fair. David R. Francis removed the first shovelful of dirt during the ceremony, signifying the start of the fairgrounds' construction. Photograph by Official Photographic Company, 1904. P0166-00118.

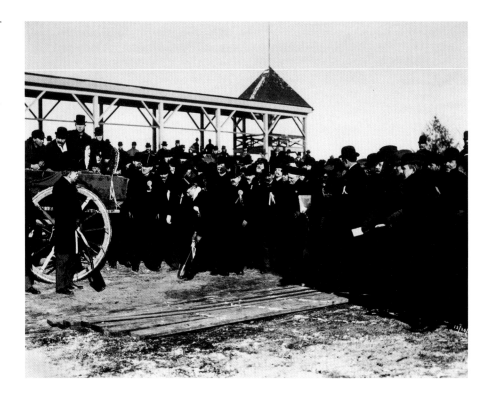

Finding items that tell multilayered stories is much more difficult, but they're a curator's dream come true.

To make concepts easier to visualize, historians often talk in numbers. The Fair is no different. Nearly 20 million people attended. At 1,272 acres, it was the largest of any Fair to date. The Palace of Agriculture alone spanned 23 acres. More than 60 nations participated and brought exciting new inventions with them.

We talk about the Fair as an absolute triumph. We boast that St. Louis cleaned up its water to create the glistening Cascades that majestically flowed down Art Hill, that we built new facilities to house out-of-town visitors. We talk about how much money the Fair made, that it was the only profitable turn-of-the-century Fair. In its grandeur and wonder, the Fair is upheld as one of the city's proudest achievements, but its complexities are rarely discussed. It is seldom mentioned that the anniversary the exposition commemorated—the Louisiana Purchase of 1803, which nearly doubled the size of a young United States—displaced large numbers of people. Rarely are these people who were forced to come to St. Louis to "live" at the Fair even addressed.

Fair planners billed the event as one of process, not just product. It was about educating the fairgoer on how something was made and how the latest technology made its creation possible. Organizers pointed to the Philippine Village as an example of the United States' latest conquest that would greatly enhance the nation. They promoted the Filipinos who lived at the Fair as a way for visitors to learn about this new culture, as proof that American colonialism was badly needed in more

"primitive" parts of the world. In reality these people were displaced from their homeland and then asked to live as naturally as possible while strangers watched their every move. And even in their "natural habitat," white women taught them Western songs and dances.

There are issues that arose from St. Louis stealing the Olympics from Chicago. It turns out it was not the best idea to have both the Fair and the Games happening at the same time. And it wasn't enough for St. Louis to host the first Olympics in the United States at the 1904 World's Fair. Fair organizers went a step further and devised an event called Anthropology Days, when people from different ethnic groups exhibited at the Fair were asked to compete with athletes in modern Western events to see who was more evolved, more superior. Of course, people from these ethnic groups were largely unfamiliar with Western sports, so they rarely did well, thus making them look uncivilized and turning the Games into a spectacle.

The authors of the following essays all speak about the World's Fair as a multifaceted event. They give context to its wonder and confront its complexities head-on. Combined, these essays tell a more holistic story, a truer account of what the Louisiana Purchase Exposition was all about.

Kristie Lein examines the national palaces countries built on the fairgrounds and how the items they exhibited there were intentional choices meant to convey the way they wanted to be seen by the outside world—and maybe even change the position they held in it. Dave Walsh illustrates how the Fair's organizers used spectacular displays of new wireless technology to prove that Western modernity had won the present and would go on to win the world. Using World's Fair portraits, Elizabeth Eikmann shows how photographers often staged their subjects in ways that would reinforce stereotypes or push certain narratives. Filipino American Ria Unson discusses how discovering that her Filipino great-grandfather worked as a guide at the Fair brought her a greater understanding of the origins of stereotypes and her ongoing struggle to reclaim her identity. Peter Tao, a second-generation Chinese American, writes about how Chinese people were perceived in the United States at the turn of the century and how they were largely excluded from participating in the very event that they had helped build. Linda Nance and Arthelda Busch Williams discuss the World's Fair experience of the National Association of Colored Women—and why it ended in a widely publicized boycott.

As a curator, I appreciate each of these stories for how they help piece together a more complete picture of what fairgoers and Fair workers might have experienced over those seven months in 1904. May we always seek to learn more about this story—and others—by listening to the voices of those who have stories to share.

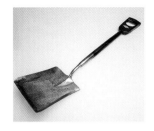

Shovel used by David R. Francis for the ground-breaking of the 1904 World's Fair. It was later used in the groundbreaking of the Jefferson Memorial Building, now the Missouri History Museum. Made by St. Louis Shovel Company, 1901. 1901-031-0001.

Sharon Smith is the Missouri Historical Society's curator of civic and personal identity. She has studied the 1904 World's Fair throughout her 35 years at MHS, and she's contributed to three World's Fair exhibits. Additionally, Smith oversees many of the institution's collections, including the Charles Lindbergh Collection, the Gateway to Pride Collection, and those related to sports, toys, and dolls.

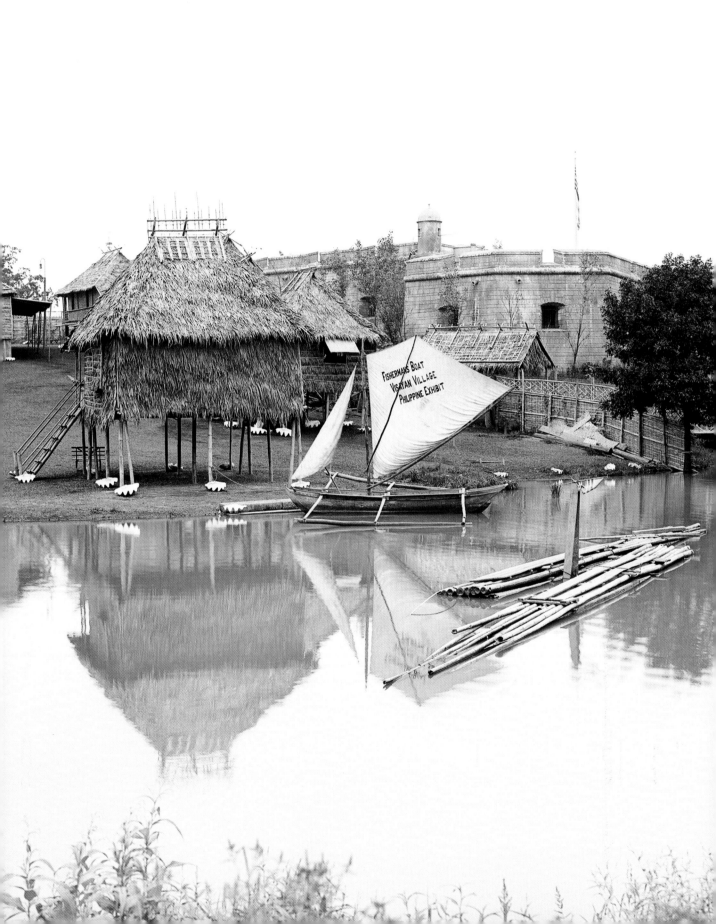

FILIPINOS AT THE 1904 WORLD'S FAIR
A Legacy of Race and Empire

By Ria Unson

L ike, 'Meet me in St. Louie, Louie'?" my grandmother Daisy asked, puzzled, when I told her I was moving to St. Louis in 1996. The Judy Garland song was her only context for the city. Daisy lived in Manila, the capital of the Philippines, and until I was 13 years old, I lived there with her. To be honest, St. Louis had not been on my radar either. What brought me to St. Louis (not unlike many others) was a college boyfriend hailing from this midwestern "small city, big town" who moved back for his family. So it was a complete surprise when I discovered, quite by accident, that my own story and the city's history were entwined in a cultural inflection point that St. Louisans cannot quit: the 1904 World's Fair.

In 2018, I was soon to be an empty nester. At the time, I had no known ties to the city, and I was actually daydreaming about what it would be like to return to my birth country. In a moment of homesickness, I even said out loud to no one in particular, "Why am I even here?"

Three days later, with the help of the all-knowing gods of Google, I stumbled upon a document and an image of Ramon Ochoa at the World's Fair. Ramon was Daisy's father,

A sailboat floats in Arrowhead Lake in the Philippine exhibit. The Walled City of Manila is in the background. Photograph by F. J. Koster, 1904. P0166-078-8g.

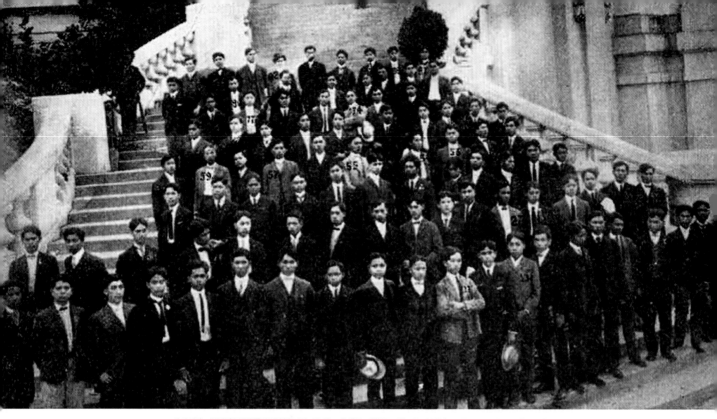

1903 PENSIONADOS AT ST. LOUIS EXPOSITION

my great-grandfather. In the black-and-white picture, 100 boys are standing on the steps of Festival Hall. This discovery led me down a rabbit hole, further revealing that not only had my great-grandfather and I lived in the same city—albeit over a century apart—but also that I lived in DeMun, the neighborhood where the Fair's Philippine exhibit had been located. It felt weirdly like fate, or that my great-grandfather was reaching across time to answer my question.

Today the 1904 World's Fair's anthropology exhibits are well known as "the largest human zoo in world history," and the Philippine exhibit was the largest yet of those, both in population and footprint.[1] The exhibition's official brochure boasted "over 40 tribes of indigenous people from across the Philippine islands." By digging around, I further learned that the Philippine exhibit cost $1.5 million in 1904—that's $51.9 million today. One can imagine my astonishment and why I kept searching for more information: Why were Fair organizers so interested in the Philippines that they would go through all the trouble and expense of staging this display?

This is how I first learned about the Philippine-American War and the United States' subsequent 47-year occupation. I attended elementary school in the Philippines and high school and college in the United States. Surprisingly, these topics weren't covered in my formal education in either country.

My independent research first led me back to 1898 and the Spanish-American War. I learned that the first shot fired in the conflict between Spain and America took place in Manila Bay. I learned that to avoid conceding defeat to the Filipinos in the Philippine Revolutionary War, Spain sold the Philippines to America for $20 million, ignoring that the first Philippine Republic had already been formally established in June 1898.

As I continued my deep dive into history books, primary documents, and scholarly articles, I stumbled upon stories from the Philippine-American War, like the one about the Balangiga Massacre, which took place in September 1902. The Filipino villagers of Balangiga staged an uprising against an occupying American battalion, killing 54 of the 78 soldiers. In the aftermath, US Brigadier General Jacob Smith told his subordinates, "I want no prisoners. I wish you to kill and burn; the more you kill and burn the better it will please me." When asked for specifics for his kill orders, Smith said, "Kill everyone over 10." In the following months an estimated 15,000 Filipinos died on the island of Samar in retaliation for the uprising in Balangiga.[2] Of course the "incident" made headlines in US newspapers, as did other war atrocities—including the now infamous "water cure," a form of torture that was ostensibly introduced by American soldiers in the Philippines, where the subject is first bound and forced full of water through the throat until his stomach is full. The water is then forced out of him by pressing a foot or plank on his stomach.

President William McKinley claimed that his decision to occupy the Philippines came to him while on his knees praying for guidance: "And one

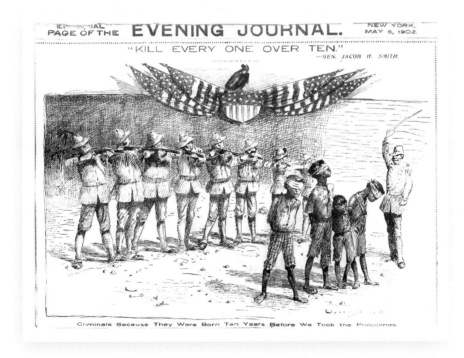

"Kill Every One Over Ten." Editorial cartoon by Homer Davenport published in the *Evening Journal*, May 5, 1902. Public domain.

night late it came to me this way—I don't know how it was, but it came. . . ." From his epiphany, McKinley concluded "that there was nothing left for us to do but to take them all, and to educate the Filipinos, and uplift and civilize and Christianize them and by God's grace do the very best we could by them, as our fellow men for whom Christ also died."[3]

However, not all Americans were so assuaged. Ambivalence was fueled by vocal proponents on either side of the imperialist debate. Mark Twain, vice president of the Anti-Imperialist League, said, "I am opposed to having the eagle put its talons on any other land." Andrew Carnegie even offered the US government $20 million to buy back Philippine independence.

This was the broader political and social context in which former Missouri governor David Francis and members of the World's Fair Commission were operating as they planned the Louisiana Purchase Exposition: the continued fever dream of American expansion and concerns about growing opposition from the public.

As someone who has spent my entire professional career in marketing and communications, I couldn't help but notice how hosting a World's Fair at this particular moment in the nation's history would shape public opinion. Certainly the thought must have occurred to the power brokers of the time. William Howard Taft, then the governor general of the newly conquered US territory of the Philippines, even said that the Fair would exert "a very great influence on completing the pacification of the Philippines by creating a cadre of Filipinos who would be informed about the wonders of modern civilization and overawed by its inexorability."[4] This is why I think of the Philippine exhibit at the World's Fair as actual material evidence of the moment America chose to become an empire.

Not only could the Fair influence Filipinos, but it would also mold American minds:

> The exhibits at the fair were explicitly designed, in the words of David Francis, to teach the "working citizenry" of the United States "about the proper classification, correlation, and harmonization of capital and labor"—about capitalism as a form of racial progress. The fair exhibits were designed to domesticate the restive immigrant workers of St. Louis by turning them into white people.[5]

It was clear from the words of Fair organizers that the event did indeed have a specific communication strategy beyond simply bringing the world to St. Louis. It would also editorialize and curate the world in a way that furthered a capitalist and racial agenda. William McGee, head of the Fair's Department of Anthropology, said the exhibits were "to use living peoples in their accustomed avocations as our great object lesson. . . . To represent human progress from the dark prime to the highest enlightenment."[6] Frederick Skiff, the Fair's director of exhibits, said, "Over and above all the fair is the record of the social conditions of mankind. Registering not only the culture of the world at this time but indicating the particular plans

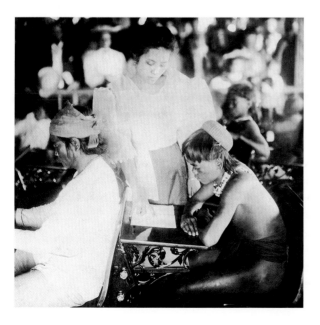

Igorot Village on the Philippine Reservation.
Photograph by Jessie Tarbox Beals, 1904. N20682.

Pilar Zamora, a Filipino teacher, teaching an Igorot student in the Philippine Reservation's Model School. Unknown photographer, 1904. N37281.

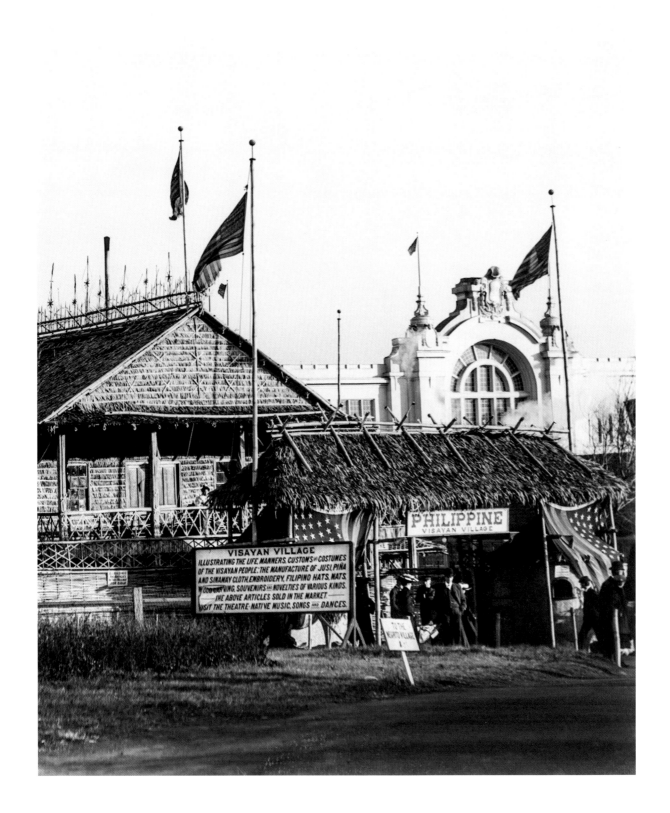

FILIPINOS AT THE 1904 WORLD'S FAIR

along with which different races and different people may safely proceed, or, in fact have begun to advance towards a still higher development."[7]

Some scholars call events like the Fair a forward-facing projection, meant to indelibly imprint specific kinds of memories by creating firsthand narratives that would be passed down to future generations. To this end, every aspect of the fairgrounds was intentionally designed to create an unforgettable, immersive experience. For example, most Fair visitors arriving at the fairgrounds by train would first see the 200-foot-tall neoclassical spectacle of Festival Hall crowning the 90-foot-high Cascades. A look at a map of the Fair shows that to get to the Philippine exhibit, a visitor coming from Festival Hall would have to walk a substantial distance, passing multiple palaces, lagoons, and manicured walkways. Furthermore, the exhibition halls at the Fair were referred to as "palaces." The word *palace* comes from the Latin *Palatium*, the hill in Rome where the emperor lived—curious, considering that America famously has no kings.

Visitors would have had to venture beyond the Palace of Agriculture, the Fair's westernmost palace, and across Arrowhead Lake on one of three bridges. The view from the ground in the Philippine exhibit told quite a story: hastily built thatched huts in the foreground, an ornately embellished palace looming in the background, and a moat separating the world of the "primitive" from the world of "progress."

What was not well represented at the Fair or in the memories of those who attended was that the Philippines did not only consist of tribal villages but also had towns and densely populated cities such as Manila, where I grew up. These cities, invisible to fairgoers, were also the sites of America's invasion and occupation.

In addition to the fairgrounds' spatial design, brochures and guidebooks for the Philippine exhibit were explicit in their racial messages:

"The Iggorotes, head-hunters and dog-eaters, from Uncle Sam's Island domain, are very comfortable in their quarters at the Exposition. . . ."

"The Iggorrote is a pagan, a barbarian culture. . . ."

Thus, Fair attendees "saw for themselves" that McKinley was right: The Filipinos had to be Christianized. Visitors could easily ignore that the Spaniards had already brought "the light of Christ" to the islands some 300 years before.

The World's Fair Commission hired photographers, such as the Gerhard sisters and Jessie Tarbox Beals, to document the anthropology exhibits so they would continue to live on in the archives and be recirculated forever for those of us who were unlucky enough to have missed attending the "greatest fair the world has ever seen."[8] Their photographs presented what appeared to be peaceful domestic arrangements in the Philippine islands while effectively erasing the terror of American invasion and occupation—the reason for the Philippines' presence at the Fair in the first place.[9]

Entrance to the Visayan Village on the grounds of the Philippines exhibit. The contrasting façade of the Palace of Agriculture is visible in the background. Photograph by Official Photographic Company, 1904. P0166-485-4g.

What role did my great-grandfather play in all of this? Why was he brought here? I learned that he was in the inaugural class of *Pensionados*, the scholarship program established by none other than Governor General Taft in 1903. Perhaps this is what Taft meant about "establishing a cadre of Filipinos to be overawed by modern civilization." The program sent students who passed an English proficiency exam to attend American universities. The first assignment for the class of 1903 was to serve as guides in the Philippine exhibit in St. Louis, where a Pensionado would spend his day "showing aliens his familiars."[10] My great-grandfather's "cadre" arrived on August 5, 1904, and they stayed for a month.[11] On August 13, the 100 Pensionados marched in the "parade of progress." They were presented in contrast to the native tribespeople as "the last stage in an evolutionary schema of development," reinforcing yet again the narrative of the civilized West against the primitive "rest."[12]

The Pensionado program was structured such that when the students graduated and returned to the Philippines, the Pensionados would fill civil positions in the colonial government. As it turned out, alumni of the program would eventually become justices of the Supreme Court of the Philippines, national architects, politicians, secretaries of various departments, and so forth. In part through their influence, Filipino culture would, in short order, mirror America's.

My great-grandfather Ramon did in fact go back to the Philippines informed of the wonders of Western civilization, just as Taft intended. He rose in the ranks of the Philippine Constabulary and spent his career fighting alongside American troops against Filipino "insurgents." He passed away long before I was born, but there is evidence of his indoctrination through the generations.

For example, he named his daughter (my grandmother) Daisy—not a typical Filipino name. Daisy spoke English with an American accent even though she lived her entire life in the Philippines. She chose to study English in college, and she would often remind me of how lucky we were to be the only Asian country that spoke English.

It is said that Spain colonized with religion while America colonized with education. Both soldiers and teachers were deployed across the islands as part of what McKinley called the Benevolent Assimilation Proclamation. His argument was that America was giving Filipinos the "gift" of English. In contrast, Filipino historians refer to it as "US language terrorism."[13]

Daisy would marry Miguel Unson, who went by his Americanized name, Mike. Mike got his graduate degree in the United States in the early 1940s. Two of their children would study in the US as well. Eventually, I would also choose to go to the States. So, one can see how the path to my American education was paved with generational precedence. My choice seemed like the most natural decision in the world. Notably, my half-sisters on my mom's side who don't share Ramon's lineage were not predisposed to come to the US.

I did not anticipate being perceived any differently than anyone else in America. My experience in the Philippines was as an extension of the United States: We watched American TV shows, we ate Pop-Tarts, there was a McDonald's on every corner, and we spoke American English at home and at school. I found a quote

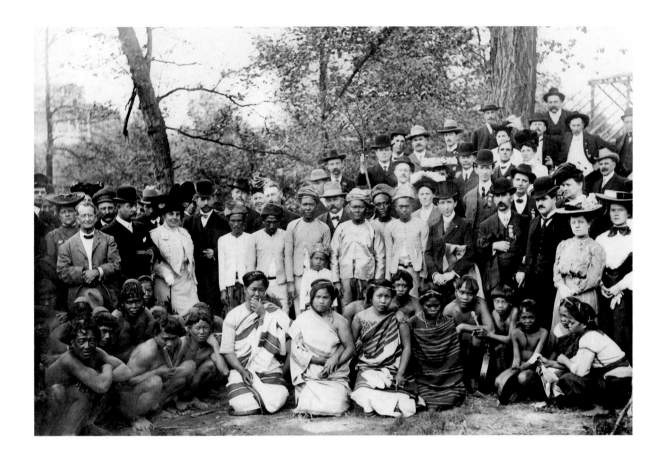

in a 1908 edition of the *Manila Times* by a newspaper editor from Missouri. She wrote, "Manila is the most thoroughly typical American city I have ever visited outside the United States."[14]

With my recent crash course in history, I became really interested in memory— what is remembered and what is forgotten—because when I moved to Madison, Wisconsin, 81 years after the Fair, the most common questions I got from my fellow high school classmates were "Do you eat dogs?" and "Did you live in a tree?"

Manila has a population of over 14 million people. I grew up in the financial district. With its skyscrapers and 24-hour bustle, it bears some resemblance to Lower Manhattan. My classmates' questions made no sense to me until decades later, when I went to the archives at the Missouri Historical Society's Library & Research Center and read those phrases in the brochures advertising the Philippine exhibit at the Fair: *They eat dogs. They live in tree houses.*

Just as my great-grandfather had been there, I envisioned my classmates' ancestors coming to the Fair. David Francis reported that almost 20 million people attended and that the Philippine Reservation was the most popular exhibit.

Even though admission cost an extra 25 cents, 99 percent of Fair attendees from all over the country paid to see the Filipino exhibit.[15] It's not a stretch to think that families came to the Fair from nearby states like Wisconsin. In fact, it was clearly the intent of Fair organizers that attendees would be "educated" in this way.

Those impactful firsthand experiences have been further perpetuated through every book, article, commemorative spoon, and documentary about the World's Fair since then, making sure that the event and its embedded ideologies would never be forgotten. And sure enough, the beliefs about Filipinos endured four generations to confront me, who, in Wisconsin in the '80s at Monona Grove High School, was the first and only Filipino my classmates had ever met.

It was only decades later that I realized how questions like this contributed to my feeling othered and exoticized, and to the pressure I felt to assimilate, which in turn led to many choices on my part that resulted in the loss of my birth culture. Although unconsciously done, I see now how hard I worked to convince everyone around me (and myself) that I was just like them instead of a dog-eating savage who lived in a tree. Throughout high school and college, I was often the only Asian—definitely the only Filipino—in the room. Friends commented that they didn't think of me as Asian at all, and that was meant to be a compliment. This whitewashed version of myself was socially acceptable, the "model minority" who was a good student, a good worker, who improved the optics of my schools and employers by allowing them to check all their diversity boxes. Eventually, I settled in St. Louis with my white (now ex) husband.

Man identified as a "Bontoc Igorrote" on the Philippine Reservation. Unknown photographer, 1904. N28511.

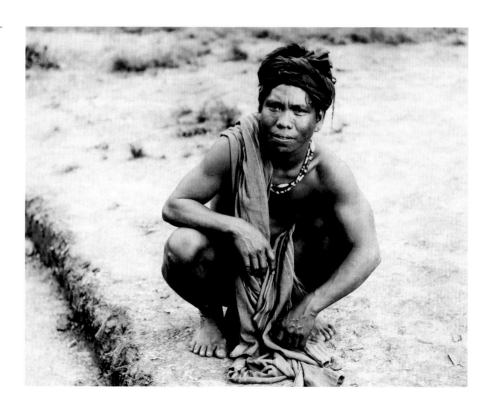

FILIPINOS AT THE 1904 WORLD'S FAIR

My ongoing struggle to reclaim my identity and find belonging is represented in my visual art, which I use to examine and interrogate the enduring legacy of American colonialism. I'm driven by a desire to more fully understand the life that I live today, one that I thought was the result of my choices, but in reality was shaped by early 20th-century US foreign policy.

The machinations of Taft, McKinley, and Francis—that is how you end up with a person who looks like me yet whose first language is American English; who was born in Manila and lives in St. Louis; and whose livelihood promotes American higher education. I was designed. And the World's Fair, in the way it simultaneously imprinted on my great-grandfather and on all the attendees, was an instrument of that design.

What I've come to understand more fully is that the colonizing of minds is not limited to people like me whose land was colonized. Every one of us has been shaped by this history. So many of the societal challenges we face today in St. Louis and around the world more broadly stem from people continuing to perpetuate ideas without truly examining them and their origins. One hundred and twenty years ago, *all* of our great-grandparents were imprinted with memories of much more than just a giant Ferris wheel and waffle cones.

William Howard Taft and David R. Francis at the Philippine Reservation. Unknown photographer, 1904. N20679.

Ria Unson is a Filipino American visual artist and speaker based in St. Louis. Through her art practice and speaking engagements, Unson expands the collective archive to include stories about Filipino and American history that have been historically erased and/or excluded.

Endnotes

1. Walter Johnson, "The Largest Human Zoo in World History," *Lapham's Quarterly,* April 14, 2020.

2. Andrew Feight, "General Jacob H. Smith & the Philippine War's Samar Campaign," *Scioto Historical*, accessed December 11, 2023, https://sciotohistorical.org/items/show/109.

3. General James Rusling, "Interview with President William McKinley," *Christian Advocate*, January 22, 1903.

4. Walter Johnson, *The Broken Heart of America: St. Louis and the Violent History of the United States* (New York: Basic Books, 2021).

5. Matthew Frye Jacobson, *Whiteness of a Different Color: European Immigrants and the Alchemy of Race* (Cambridge: Harvard University Press, 1999).

6. Robert Rydell, *All the World's a Fair: Visions of Empire at American International Expositions, 1876–1916* (Chicago: University of Chicago Press, 1984).

7. Ibid.

8. *The Complete Portfolio of Photographs of the World's Fair, St. Louis, 1904* (Chicago: The Educational Company, 1904).

9. Laura Wexler, *Tender Violence: Domestic Visions in an Age of U.S. Imperialism* (Chapel Hill: University of North Carolina Press, 2000).

10. Gina Apostol, *La Tercera* (New York: Soho Press, 2023).

11. Kenneth W. Munden, *Los Pensionados: The Story of the Education of Philippine Government Students in the United States, 1903–1943* (Washington, DC: National Archives, 1943)

12. Talitha Espiritu, "Native Subjects on Display: Reviving the Colonial Exposition in Marcos' Philippines," *Social Identities* 18, no. 6 (2012), 729–744.

13. E. San Juan Jr., "Inventing Vernacular Speech Acts: Articulating Filipino Self-determination in the United States," *Socialism and Democracy* 19, no. 1 (March 2005): 136–154.

14. Albert Samaha, *Concepcion: Conquest, Colonialism, and an Immigrant Family's Fate* (New York: Riverhead Books, 2022).

15. David R. Francis, *Universal Exposition of 1904,* vol. 2 (St. Louis: Louisiana Purchase Exposition Company, 1913).

References

Apostol, Gina. *La Tercera*. New York: Soho Press, 2023.

The Complete Portfolio of Photographs of the World's Fair, St. Louis, 1904. Chicago: The Educational Company, 1904.

Espiritu, Talitha. "Native Subjects on Display: Reviving the Colonial Exposition in Marcos' Philippines." *Social Identities* 18, no. 6 (2012): 729–744.

Feight, Andrew. "General Jacob H. Smith & the Philippine War's Samar Campaign." *Scioto Historical*, accessed December 11, 2023. https://sciotohistorical.org/items/show/109.

Francis, David R. *The Universal Exposition of 1904*. 2 vols. St. Louis: Louisiana Purchase Exposition Company, 1913.

Frye Jacobson, Matthew. *Whiteness of a Different Color: European Immigrants and the Alchemy of Race*. Cambridge: Harvard University Press, 1999.

Johnson, Walter. *The Broken Heart of America: St. Louis and the Violent History of the United States*. New York: Basic Books, 2021.

———. "The Largest Human Zoo in World History." *Lapham's Quarterly*, April 14, 2020.

Munden, Kenneth W. *Los Pensionados: The Story of the Education of Philippine Government Students in the United States, 1903–1943*. Washington, DC: National Archives, 1943.

Rusling, General James. "Interview with President William McKinley." *Christian Advocate*, January 22, 1903.

Rydell, Robert. *All the World's a Fair: Visions of Empire at American International Expositions, 1876–1916*. Chicago: University of Chicago Press, 1984.

Samaha, Albert. *Concepcion: Conquest, Colonialism, and an Immigrant Family's Fate*. New York: Riverhead Books, 2022.

San Juan Jr., E. "Inventing Vernacular Speech Acts: Articulating Filipino Self-determination in the United States." *Socialism and Democracy* 19, no. 1 (March 2005): 136–154.

Wexler, Laura. *Tender Violence: Domestic Visions in an Age of U.S. Imperialism*. Chapel Hill: University of North Carolina Press, 2000.

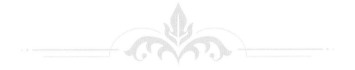

AN AUTHENTIC VIEW OF PROGRESS
Photography and Anthropology at the 1904 World's Fair

By Elizabeth Eikmann

When the Louisiana Purchase Exposition opened in 1904 St. Louis, it spanned 1,272 acres—the largest World's Fair ever held in the United States. Historically, hosting cities used their global platform to focus on some aspect of nation-building, using the event's framework to advance different ideological messages. In the early 20th century, US Fairs began to reiterate ideas about imperial power and American paternalism, pointing to the developing field of anthropological sciences to emphasize white racial superiority. For visitors, the Fair offered many opportunities to experience and express their national pride—and to do so in an environment that reaffirmed ideology about white supremacy. The World's Fair in St. Louis was no different.

The Louisiana Purchase Exposition planners cited anthropology's so-called objective truths as proof of racial hierarchy. Prior to the 1880s, anthropological inquiry was typically a museum-based or leisurely pursuit of study. It was not until much closer to the turn of the century that the field was recognized as a professional one. In fact, it was anthropology's

The Tyrolean Alps that loomed over the Pike were made from reinforced plaster—just one of many illusions fairgoers encountered. Photograph by Jessie Tarbox Beals, 1904. N20734.

relative infancy that offered an "added benefit" to Fair organizers. According to anthropologists Nancy Parezo and Don Fowler in their book *Anthropology Goes to the Fair*, the field's newness equipped it with the ability to offer a "better" and more progressive form of scientific inquiry.

As such, the Department of Anthropology became one of the Fair's biggest draws, and the "living exhibits" were at its center. The exhibits featured more than 2,000 people from around the world who were brought to St. Louis—some by choice, others forced—and put on display in a series of villages. According to John Hanson in *The Official History of the St. Louis World's Fair*, "it was [the anthropology] department which not only bound together the Louisiana Purchase Exposition as a whole, but gave to it its broadest, highest, and grandest significance."[1] As the department's director, William McGee, put it, "The special object of the Department of Anthropology [was] to show each of the world how the other half lives and thereby to promote not only knowledge but also peace and good will among nations. . . ."[2]

The attempt to "show each of the world how the other half lives" manifested as a laser focus on the development of "authentic" anthropological villages that conveyed a narrative of national and racial "progress" linked with white supremacy. This narrative of progress, according to McGee, was more than just scientifically accurate; he believed it was "a matter of common observation" that "the white man can do more and better than the yellow, the yellow man more and better than the red or black. . . ."[3]

To further this message, anthropologists scrutinized and regulated every aspect of the Fair's exhibits to ensure their "authenticity," going so far as to control practices and behaviors, such as the diet and dancing of the people on display.[4] As documentary filmmaker Eric Breitbart wrote, "Many visitors to the fair had read about the Battle of Santiago Bay, the Boer War, and the Galveston flood in the newspapers. . . . For a few cents, visitors to the fair could walk through Mysterious Asia, tour the Philippine Reservation or a Bavarian Beer Garden; they could kiss the Blarney Stone, experience the feeling of being transported from New York City to the North Pole, climb an Indian cliff dwelling, or peer inside a Filipino hut, then return safely to a St. Louis hotel or boardinghouse."[5]

The level of "authenticity" was, of course, defined less by how those on display and their home nations really were and more by how Fair planners believed them to be. Selling tickets, attracting visitors, and subtly (and not so subtly) reinforcing elements of racial hierarchy determined the bounds of authenticity. In short, World's Fairs held in the United States "supported the proposition that the advance of the American industrial economy, as directed by Anglo-Saxon elite, was synonymous with national progress."[6] Ideas about science, race, and imperial power were represented, packaged, and sold to Fair visitors in every way possible.

"Authentically" representing the world's people at the Fair meant crafting a worldview through the lens of race science and portraying the Western world—specifically

the United States—as the most civilized, with other nations falling into place in the hierarchy based on racial characteristics. This system of characterization classified people from across the world according to "types" that positioned them along a spectrum of slow progress toward achievement of the highest level of development. The frontispiece of 1904's *Louisiana and the Fair,* a comprehensive, multivolume overview of the Fair, illustrates this exactly (see page 65).

Called *Types and Development of Man,* the photogravure features 12 illustrated portraits of the world's "types" surrounding a full-body portrait of a white woman who holds a book and a lit torch. A dark-complexioned figure sits in the shadows behind her. The book's author explains that the woman, called "Intelligence," holds the "torch of Enlightenment and book of Wisdom," lighting the "dungeon of savagery," standing on top of those at the "lowest" stages of development. The man in the shadows is called "Ignorance," and he "skulk[s]" at the woman's attempt to offer direction toward "better conditions, moral, intellectual, and social."[7]

To best visualize these complex theories, Fair planners relied heavily upon comparative contrasts, often placing the "civilized" alongside the "uncivilized" to highlight their differences. As historian Robert Rydell states, "The road map to future perfection offered by the exposition directors . . . involved a comparative dimension" that "hinged on the contrast between 'savagery' and 'civilization.'"[8] Fairgoers in St. Louis experienced this imperial vision in the physical landscape of the Fair as they walked through the Philippine Reservation.

The Philippine Reservation was a kind of Fair inside a Fair, with a military museum and three main exhibition sections, each one emphasizing the past, the present, and an imagined future of the Philippines' peoples and cultures. The exhibitions were aligned chronologically so that visitors could "witness" progress as they slowly walked through the Philippines' journey toward civilization. Visitors experienced the Philippines' past as a Spanish colony with a small town square and colonial-era buildings. Its present was portrayed in the form of small island tribes and villages of "Igorots," various peoples who inhabited the northern mountainous region of Luzon. And its imagined prosperous and civilized future, made possible thanks to US intervention, was represented by the Philippine Scouts and Constabulary, a group of about 700 uniformed men who "policed" the reservation.[9]

In addition, the Philippine Reservation's geographic location on the fairgrounds reinforced the Fair's imperial vision. Placed between the Palace of Agriculture and the Indian School Building, it represented a conquering of the natural world on one side and that of humanity itself on the other. Seemingly, there was nothing that could not—or should not—be conquered and tamed by the United States.

In another instance, a World's Fair photographer named Jessie Tarbox Beals captured a photograph that visualized the Fair's comparative dimension so perfectly that it actually gained her a Fair press pass, which she had been previously denied. Citing Beals's photo "Comparison between Pygmy, 25 Years Old and Patagonian, 16 Years Old," historian of visual culture Laura Wexler argues that the photographer has created "a comparison by size that imaged the anthropometric premise of the fair—the belief that the essential information about where a group of people fell in the evolutionary ladder could be gleaned from their physical characteristics."[10]

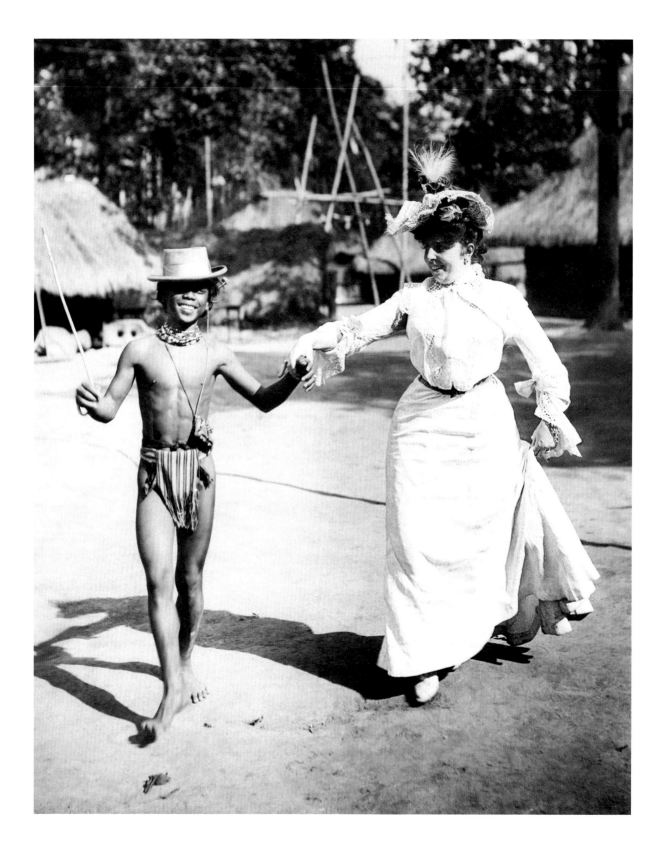

AN AUTHENTIC VIEW OF PROGRESS

This comparative element is especially apparent in photographs of white Fair visitors and the people placed on display in anthropological exhibits. For example, one of Beals's photographs features a white woman giving Filipino subjects a singing lesson; in another, a different white woman is teaching a boy how to do the cakewalk. The main visual focus of these photographs is the stark contrast between the fully clothed Western white women and the young Filipino boys. Two more of Beals's photographs feature young Filipino men. In one they wear Western-style dress, and another is labeled "As the [Board of] Lady Managers Wanted to Have Them," a reference to Fair leaders' objections to the men's more traditional—but scant—clothing. When examined together, these photographs, and others like them, assert a comparative visual rhetoric that emphasizes themes of "civilized" and "uncivilized"—of progress as advanced only by the white elite.

According to historian James Gilbert, World's Fair directors and planners wanted the Fair to "summarize the best of civilization and to explain the positive dynamics of continued progress for the twentieth century with, of course, St. Louis at the center of it all."[11] These ideas were embedded in every aspect of the event, so much so that the Fair's president, David R. Francis, claimed, "So thoroughly does [the Fair] represent the world's civilization that if all man's other works were by some unspeakable catastrophe blotted out, the records here established by the assembled nations would afford all necessary standards for the rebuilding of our entire civilization."[12]

A woman teaching an Igorot boy from the Philippines the cakewalk. Photograph by Jessie Tarbox Beals, 1904. N16487.

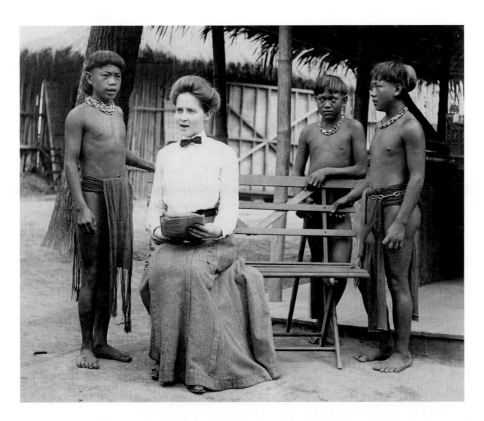

A woman giving a singing lesson to three Igorot boys. Photograph by Jessie Tarbox Beals, 1904. N28350.

Igorots dressed in Western-style clothing in the Philippine Village. Photograph by Jessie Tarbox Beals, 1904. N37001.

Photographs were central to the important project of the "record keeping" Francis described. Fair planners were no doubt aware of the power of photography, and they carefully chose photographers whom they knew would capture their exact vision. The introduction to *The Forest City,* a published collection of official Louisiana Purchase Exposition photographs, reiterated this vision: "The written word fails; the camera alone preserves in any degree satisfyingly the story in statuary, a thousand chapters long, of past, present and promise of the Louisiana Territory."[13]

On one hand, photographs were able to simply "[provide] assurance that the [Fair] did in fact take place, and that someone was there to witness it."[14] On the other, the link among photography, the developing field of anthropology, and theories of race science could also likely explain why organizers would be especially interested in photographing the Fair. Proof of race-science theories could be visualized by the camera in part because photography still "had an element of wonder attached to it."[15] To the turn-of-the-century American, a photographer was merely a mechanical operator, and the camera was a tool to capture a pure and objective record, one that presented the subject exactly as it was. If, as it was believed, scientific inquiry also produced objective, irrefutable truths, then photography was a likely medium with which to visualize its scientific "fact."

Just as the physical landscape of the Fair conveyed a message of progress, so too did photographs of Filipinos: They were touted as scientific proof, visual reminders

AN AUTHENTIC VIEW OF PROGRESS

of humans' march toward civilization. According to McGee, the "Pygmies" (Belgian Congo), "Igorots" (Philippines), and "Negritos" (Southeast Asia and the Andaman Islands) were the "least removed from the subhuman or quadrumane form."[16] World's Fair photographs emphasize these supposed qualities and portray the most "uncivilized" peoples almost exclusively as native to the Philippines and Central Africa.

Beals documented subjects in their "natural" environment, showing fairgoers how people from the Philippines or Africa "really" lived. Beals, among other Fair photographers, captured environmental shots that ranged from photographs of groups standing outside their huts to individuals performing daily tasks, like cooking or weaving. Beals's environmental portraits are particularly compelling. In them, an individual is pictured close-up, while a sense of his or her surroundings remains, an equal attempt to focus on both the subject and the environment. The subjects are photographed as wearing "authentic" clothing and holding a culturally relevant object, such as a weapon or pipe. The surrounding environment supports the images' "authenticity." For example, piles of bamboo or palm and coconut leaves that were used to build the huts in the background are visible. They're so convincing that they can make a viewer question whether the image was taken in a public park in St. Louis or in a tribal village in the Philippines.

Photographs such as these allowed a viewer to immediately confront an "exotic," unfamiliar, and perhaps even shocking perspective of how the "uncivilized" supposedly lived versus the way they themselves did—a way of life so different, and thus so behind, their own. By strolling through the Philippine Reservation, fairgoers could physically see the contrast. The village environments made tangible an otherwise abstract understanding of, in McGee's words, "how the other half lives."[17]

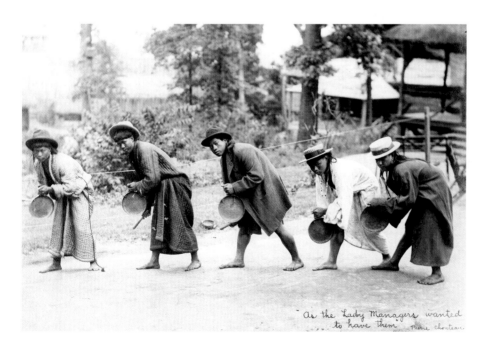

"As the Lady Managers Wanted to Have Them." There were disagreements about how the Igorots were to be dressed in the Philippine Village. If they wore Western-style clothes, they wouldn't look as "authentic." But their more traditional dress was deemed too revealing. Photograph by Jessie Tarbox Beals, 1904. N16452.

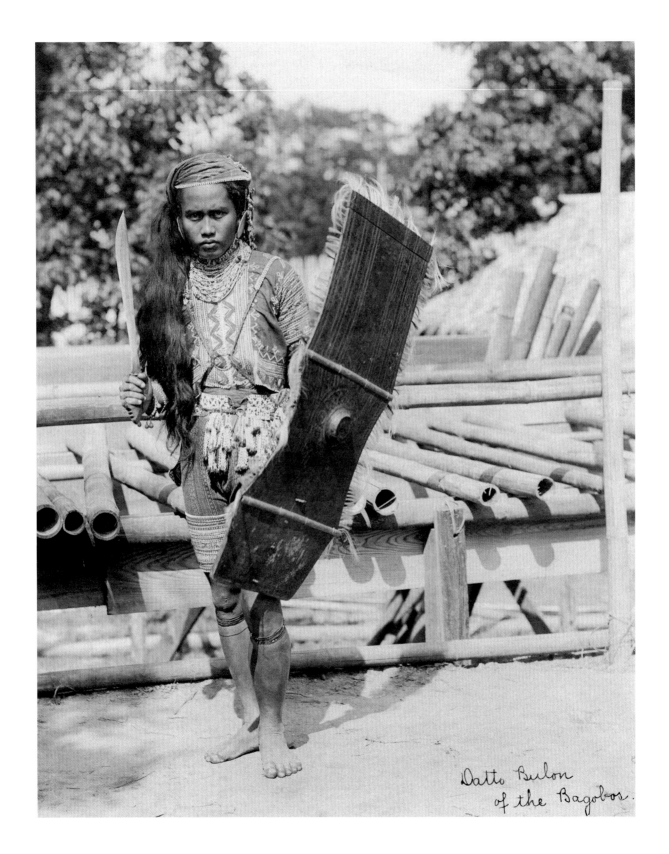

Datto Bulon
of the Bagobos.

AN AUTHENTIC VIEW OF PROGRESS

St. Louis photographers Emme and Mamie Gerhard offered an unfiltered, truthful representation of many of the very same subjects in their domestic studio portraits. Just as with Beals's environmental portraits, the Gerhards' studio portraits were meant to confirm a fairgoer's initial thoughts and impulses about the world's "other half," which were rooted in the process of othering. A marked difference, though, is that the studio portraits divorced their subjects from any environmental or worldly context and presented them as merely specimens to be observed. As visual culture historian Shawn Michelle Smith writes, the "plain backdrop locates individuals within the institutional contexts that privilege identification and documentation." Studio portraits such as the Gerhard sisters' "suggest the viewer's symbolic control or domination over subjects photographed because they are, by definition, made for a viewer who will study and catalog."[18]

In the Gerhard sisters' portrait of Ota Benga—a native of Democratic Republic of the Congo who was taken from his home to be displayed at the Fair and later exhibited alongside monkeys at the Bronx Zoo—he sits, bare chested, holding an arrow upright beside him. The image, which the sisters simply titled "Cannibal," was complemented by Benga brandishing a "weapon"—his teeth, sharpened into points. The image presents Benga not as a person in his environment but in a studio setting devoid of any outside context. He is pictured as a man meant to be looked at, not seen, a specimen representative of his entire culture. Rather than recognizing that his teeth were sharpened as part of a ceremonial ritual, Benga is reduced to a symbol and branded "cannibal."

"Datto Bulon of the Bagobos." An example of a subject wearing "authentic" clothing and holding a culturally relevant object, placed in front of bamboo for "authenticity." Photograph by Jessie Tarbox Beals, 1904. N33567.

"Bogobo Chief #3." An example of a posed studio portrait, removing the subject from any environmental context. Photograph by the Gerhard Sisters Studio, 1904. N35932.

Ota Benga was bought and taken from his native Congo to be put on display in the Fair's human zoo. Benga had his teeth filed into points as a child as part of a ceremonial ritual. The Gerhard sisters named this photo "Cannibal." Photograph by the Gerhard Sisters Studio, 1904. N28117.

With one's mind filled with thoughts about the uncivilized nature of the sitter, a viewer who believed in the portrait's accurate portrayal of its sitter's essence could find visual confirmation of the subject's supposed uncivilized nature. And, in fact, this experience was one the Gerhards were known for providing. Of their studio, one patron wrote:

> [The] absence of any bustle or intimation that anything unusual is about to occur, brings to the face of the sitter a repose that disarms and allows the true self or soul to be caught by the lens in the rapid flash of the shutter, and in an instant it has caught more than a likeness, it is oneself.[19]

Thus, it was believed that a photography studio was the ideal setting in which to capture, without question, the sitter's true essence.

If it is true that the Fair offered visitors "a final opportunity to see and record" the people who should soon be assimilated into a more "civilized world," then World's Fair photographers like Jessie Tarbox Beals and the Gerhard sisters neatly documented, packaged, and presented that record in the form of photographs meant to be circulated, displayed, and kept forever as visual legacies.

In taking a walk through the World's Fair, visitors could have a supposedly "authentic" encounter with life outside the US, and then, in viewing an environmental photograph or a studio portrait, could receive irrefutable, scientifically accurate visual confirmation of their experience. In this way, both "natural" environment photographs and studio portraits worked together to offer fairgoers a complete view of why it was necessary for the United States to colonize and civilize. They conjured a vision of exactly where the people pictured fell in the hierarchy of race and, perhaps, just how dire their need to be civilized was.

It was important for Fair planners to craft their version of an authentic experience, even if they knew it wasn't truly so. As Breitbart put it, "Authenticity was often affirmed and denied at the same time."[20] They wanted the people in anthropological displays to wear only "authentic" clothing and to live in replicated environments that resembled their home nations as closely as possible, but accuracy was not a prerequisite to authenticity. For example, the Hopi snake dance was advertised to fairgoers as a daily performance and drew attention because the ritual was not traditionally performed outside of the Hopi Reservation. An outbreak of illness prevented the group of Hopi from making it to St. Louis, but the program went on anyway: Fair planners quickly recruited Pueblos to dress up and perform the dance instead. As Breitbart stated, "Exoticism and strangeness were more important than authenticity."[21]

Rather than take World's Fair records and claims at face value, historians have started to dig deeper. Anthropologists Nancy Parezeo and Don Fowler performed the painstaking research of naming as many individuals who were brought to the Fair as they could, linking them with known photographs and even potential

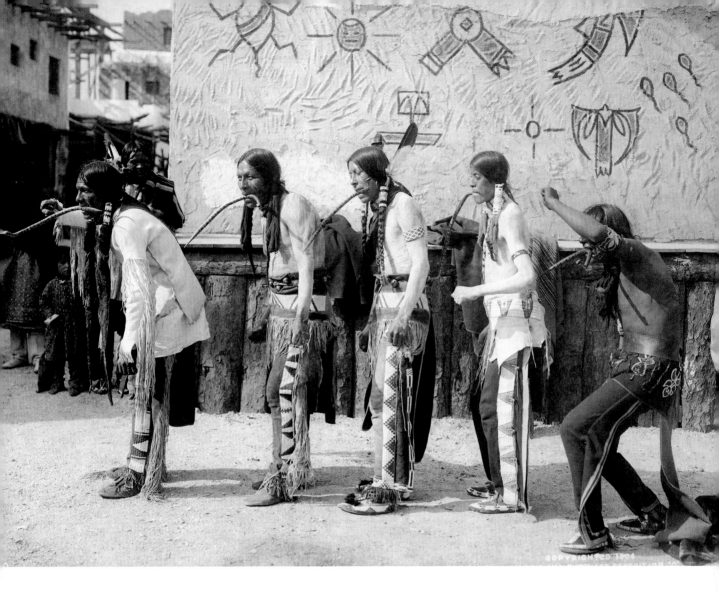

descendants.[22] Eric Breitbart worked to identify the American Indians who were photographed, as well as the tribes they belonged to. He found that Ohkay Owingeh Indians were incorrectly labeled "Navajo" in several World's Fair photographs.[23] Local historian Laura Miller evaluated one Gerhard sisters portrait titled "Geisha Girls," contending that because "the seated woman wears an ornate 'Uchikake,' a wedding kimono, which is heavily embroidered with plum blossoms and oversized chrysanthemums," that the portrait is more likely of "a well-to-do merchant wife and her daughter," rather than a pair of geishas.[24] As Breitbart wrote of another Gerhard sisters portrait, "The Gerhards also seem to have displayed an almost willful disregard for even minimal standards of accuracy."[25]

However, these findings reveal that achieving an authentic experience was more an imagination and less a reality.[26] It was far more important to create an "authentic" experience that reiterated the dominant ideology of empire than it was to create an experience that reflected reality. This is why, as Breitbart put it, "The ultimate lesson of the fair may have been less the ideas of racial harmony and

Pueblo Indians performing a snake dance not native to their culture for the entertainment of fairgoers. Photograph by Official Photographic Company, 1904. N16379.

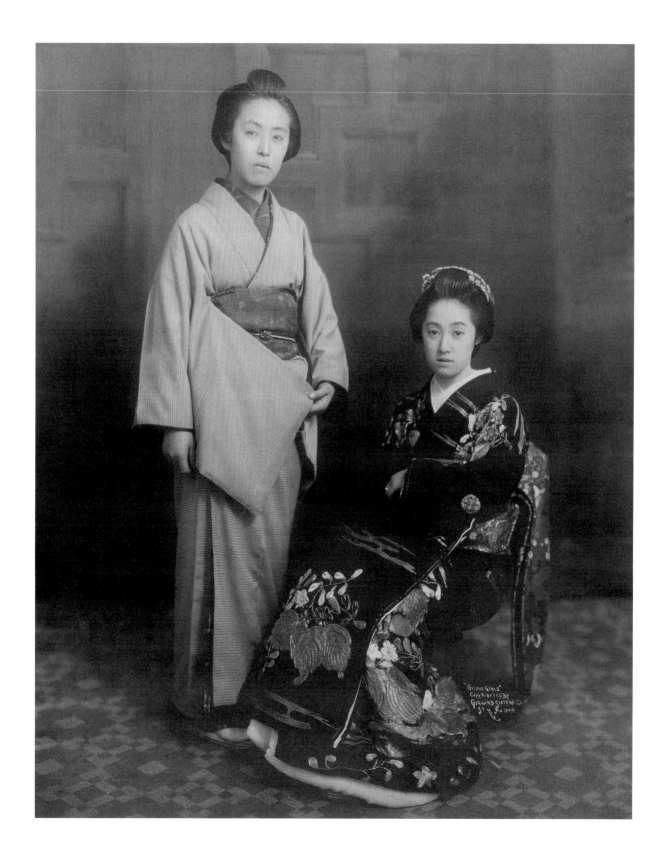

"GEISHA GIRLS"
COPYRIGHTED BY
GERHARD SISTERS
ST LOUIS 1904

AN AUTHENTIC VIEW OF PROGRESS

the orderly progression of civilization from the lowest to the highest, than that of the interchangeability of the image and the real."[27]

That said, planners' expectations and imaginations occasionally misaligned with reality in a way beyond repair. For example, fairgoers were "disappointed" in the Ainu people from Japan because according to one journalist who attended the Fair:

> The polite manners of the Ainu proved their chief mark of distinction. There was some disappointment when the band of primitive folk arrived in St. Louis. They were the hairy Ainu, true enough, but they weren't man-eaters, dog-eaters, or wild men. . . . Another disappointment in the Ainu was the cleanliness of this particular group. . . .[28]

In this case, the Ainu people did not exhibit their "uncivilized" nature in a way that was recognizable or comprehensible to the journalist, resulting in his inability to place them in the "proper" order in the racial hierarchy. In a course-correcting effort to other, however, the journalist continued: "But the arrival of the Patagonian giants forestalled possible regrets in the public mind. The Patagonian giants are primitive folk and incidentally the dirtiest people on the globe."[29]

In other cases, attempts to uphold "authenticity" at all costs were thwarted by the very people put on display. It is well documented that individuals across the fairgrounds exerted agency and resisted having their full autonomy stripped away from them by refusing to engage in some behaviors or performances, or insisting on payment for a photograph.[30] For example, Ota Benga charged 5 cents to have his picture taken with his teeth showing, and the Pygmies charged a fee to pose with machetes or to act out a beheading.[31] In other cases, people on display removed material adornments that made them look "authentic" in order to "ruin" photographs taken of them. Others refused to pose for photographs altogether.

Amateur photographer and native St. Louisan Sam Hyde visited the Fair with his camera and captured a picture of an unidentified American Indian man without his permission. Hyde recalled the incident in his World's Fair diary:

> I followed him a few paces and running quickly ahead, past him and touched the [camera] button at the supreme moment. My next thought was to get away, for the old fellow had seen my camera and heard the shutter snap. It was not a wholesome place for me to remain. As he stopped in his tracks with a savage grunt I shot across the lawn. . . . He had his feather head dress on when I spotted him and I did not know that he had taken it off till I developed the film, such was the excitement of the moment, and such the vicissitudes of Kodaking. However I doubt if he would have put it on again if I had asked him.[32]

The American Indian man recognized why Hyde wanted his photograph in the first place—because he "looked Indian"—so he removed his headdress to spoil the shot.[33]

The Gerhard sisters named this photo "Geisha Girls." However, the seated woman is wearing a wedding kimono, so it's more likely a portrait of an affluent mother and daughter. Photograph by the Gerhard Sisters Studio, 1904. N28111.

When visitors refused to pay or took a picture without the consent of the subject, Fair participants often requested that the camera be confiscated because they did not follow the established rules. Such instances were so frequent that by July 1904 cameras were forbidden inside the anthropology villages without a special permit. Even then, before taking a photograph, visitors with permits were required to ask permission and pay any associated fees. If the rules were not followed, McGee threatened to revoke all permits and ban cameras entirely.

One must consider whether claims about imperialism and white supremacy at the Fair made as much of an impression on fairgoers as the scholarship has contended. Archivist Martha Clevenger argues that it is difficult to tell. While the extent of its impact will never be fully known, evidence does indeed suggest that visitors reflected on what they had seen and learned at the Fair. For example, after visiting the Philippine Reservation, Edward Schneiderhahn remarked, "It certainly served to disseminate very useful knowledge concerning the Philippine Islands and its peoples. The exhibits, and they were plentiful, proved the high civilization already attained." Likewise, after visiting the Japan exhibit, Schneiderhahn concluded the Japanese were "[a] most patient and rapidly progressing people" and he "learned much." He took notes on the German displays and often repeated visits to lectures to "learn the lesson better."

Just as we can examine Fair photography for both what it does and does not present before the camera, we can also think about what was said and unsaid among fairgoers and interpret their silence on racial superiority as a confirmation of white supremacist worldviews. One could consider that the Fair was less "educational" in the sense that white fairgoers did not necessarily learn anything new so much as have their preexisting beliefs validated in the name of science, entertainment, and authenticity. As historian James Gilbert argues, "Hierarchy of races was first assumed and then asserted." In other words, perhaps the fairgoers' silence supports the idea that there was little for a white fairgoer to "learn" about human progress or racial hierarchy and civilization because the planners had already assumed what their knowledge and beliefs were. The World's Fair was created to confirm their already-held beliefs and give them an authoritative foundation in "authentic" displays of anthropological "fact."[34]

This silence persists even today in the way the World's Fair is commemorated and remembered. The Fair is often described as "indescribably grand": as the largest World's Fair to date by acreage, for the way it transformed Forest Park into a landscape largely incomprehensible to a contemporary visitor, as an event that attracted millions. Essays and discussions focus on maps and return to the same set of architectural photographs—in particular, Festival Hall, the Cascades, the Grand Basin—seeking to evoke a nostalgia for an event no one in the audience came close to attending. These photographs are central to both personal and collective memory of the Fair as a grand production that entertained and celebrated the growth of a great nation. This notion is, of course, an incomplete one.

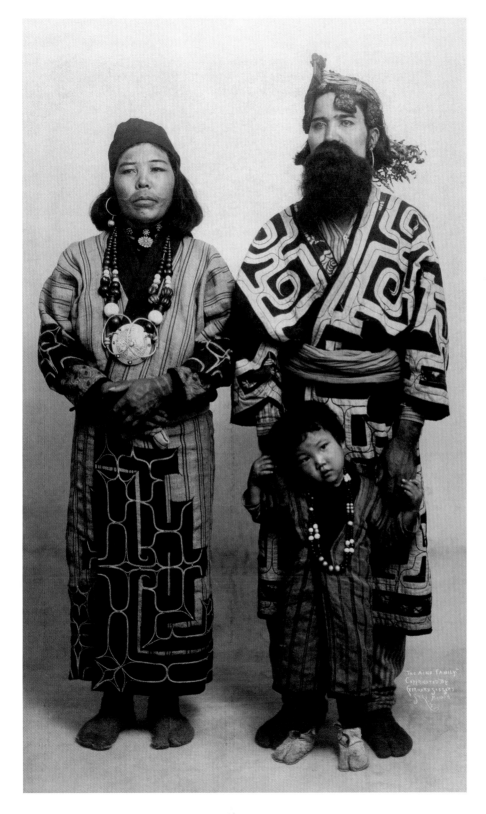

ELIZABETH EIKMANN

Photographs that focus on the "grandness" of the event have embellished our collective memory of it. When most think of the World's Fair they likely picture a view from the Grand Basin, or perhaps they see a state building, the Pike, or the Palace of Electricity. These images that highlight the Fair's physical landscape and architecture are impressive to us in part because of their temporary nature: *How could such grand structures not have been built to last?* But the physical architecture of the Fair was just as much a performance as the ideological one. Both attempted to create "authentic" experiences for fairgoers, and both were meant to emphasize the large-scale possibility of the United States as an empire.

Today we live in an age of technology. On the surface we understand that images can be manipulated, but often we fail to consider the extent to which images from the past were manipulated as well. Even though photographers did not have photo-editing software, they did have the skills to envision what they wanted their camera to capture. They used a range of techniques from lighting and exposure, to posing and background, to the choice of whom or what they did (or did not) picture. Much as they are now, photographs were used to craft a narrative, to offer a story about the subject seated before the lens—usually a story that the creator wanted to tell. When viewing historical photographs it is important to consider the larger historical and cultural context in which they were created to more fully appreciate the images' power.

Fair planners knew that, although World's Fair photographers were capturing an event "not meant to last," the messages their cameras depicted about race and US empire would be timeless. As one Fair visitor recalled in *Harper's Magazine*:

> Remember that such a fair as this that St. Louis offers leaves no intelligent visitor where it found him. It fills him full of pictures and of knowledge that keep coming up in his mind for years afterwards. It gives him new standards, new means of comparison, new insight into the conditions of life in the world he is living in.[35]

World's Fair photographs created both a memory of the past—the passage of the actual Fair, as well as the past of human progress—and a message for the future.

Elizabeth Eikmann is a teacher, scholar, and public historian with experience working with museums, public libraries, universities, and the local tourism industry. Her areas of research expertise include St. Louis history, women's history, and the history of photography. She earned her PhD in American Studies from Saint Louis University and currently works as the program coordinator in the Office of Postdoctoral Affairs at Washington University in St. Louis.

AN AUTHENTIC VIEW OF PROGRESS

Endnotes

1. Quoted in Eric Breitbart, *A World on Display: Photographs from the St. Louis World's Fair, 1904* (Albuquerque: University of New Mexico, 1997), 48; Nancy J. Parezo and Don D. Fowler, *Anthropology Goes to the Fair: The 1904 Louisiana Purchase Exposition* (Lincoln: University of Nebraska Press, 2007), 393.

2. Quoted in Breitbart, *A World on Display*, 49.

3. Quoted in Laura Wexler, *Tender Violence: Domestic Visions in an Age of U.S. Imperialism* (Chapel Hill: University of North Carolina Press, 2000), 278.

4. James Gilbert, *Whose Fair? Experience, Memory, and the History of the Great St. Louis Exposition* (Chicago: University of Chicago Press, 2009), 28.

5. Breitbart, *A World on Display,* 39.

6. Robert W. Rydell, John E. Findling, and Kimberly D. Pelle, *Fair America: World's Fairs in the United States* (Washington, DC: Smithsonian Institution Press, 2000), 25, 44–45.

7. J. W. Buel, ed. "Types and Development of Man," *Louisiana and the Fair: An Exposition of the World, Its People, and Their Achievements*, vol. 5 (St. Louis: World's Progress Publishing Co., 1904), 1.

8. Robert Rydell, *All the World's a Fair: Visions of Empire at American International Expositions, 1876–1916* (Chicago: University of Chicago Press, 1984), 182, 5. While the 1898 Trans-Mississippi and International Exposition in Omaha, Nebraska, was technically the first to introduce fairgoers to the themes of United States empire and race, the two Fairs that immediately followed were the first that explored these ideas in depth. For example, the 1901 Pan-American Exposition in Buffalo, New York, featured a "Filipino Village" that was lauded as a great success, particularly because the exhibit represented the Philippine people as "indifferent to work" and "greatly in need of American uplift and intervention." Rydell, Findling, and Pelle, *Fair America*, 50; Gilbert, *Whose Fair*, 28.

9. Rydell, Findling, and Pelle, *Fair America*, 55.

10. Wexler, *Tender Violence*, 276.

11. Gilbert, *Whose Fair*, 25.

12. Quoted in Rydell, Findling, and Pelle, *Fair America*, 53.

13. Walter B. Stevens, ed., *The Forest City: Comprising the Official Photographic Views of the Universal Exposition Held in St. Louis, 1904* (St. Louis: Thompson Publishing Company, 1904), 10.

14. Breitbart, *A World on Display*, 7.

15. Ibid., 9.

16. Parezo and Fowler, *Anthropology Goes to the Fair*, 403.

17. Quoted in Breitbart, *A World on Display*, 49.

18. Shawn Michelle Smith, *Photography on the Color Line: W. E. B. DuBois, Race, and Visual Culture* (Durham: Duke University Press, 2004), 46.

– *Continued* –

Endnotes

19. Elisabeth Beverly James, "Gerhard Sisters, St. Louis, MO," *Bulletin of Photography* 18, no. 446 (February 23, 1916): 230.

20. Breitbart, *A World on Display*, 41.

21. Ibid., 78.

22. Parezo and Fowler, *Anthropology Goes to the Fair*, 405–416.

23. Breitbart, *A World on Display*, 13.

24. Jessica Rogen, "Laura Miller Takes a Deep Dive to Elevate Awareness of Japanese Culture," *UMSL Daily* (blog), University of Missouri–St. Louis, March 26, 2019, https://blogs.umsl.edu/news/2019/03/26/laura-miller/.

25. Breitbart, *A World on Display*, 13.

26. Ibid.

27. Ibid., 50.

28. Quoted in Ibid., 66.

29. Ibid.

30. Ibid., 265.

31. Ibid., 68.

32. Quoted in Martha R. Clevenger, ed., *Indescribably Grand: Diaries and Letters from the 1904 World's Fair* (St. Louis: Missouri Historical Society Press, 1996), 132.

33. Parezo and Fowler, *Anthropology Goes to the Fair,* 271–273; Danika Medak-Saltzman, "Transnational Indigenous Exchange: Rethinking Global Interactions of Indigenous Peoples at the 1904 St. Louis Exposition," *American Quarterly* 62, no. 3 (September 2010): 598.

34. Quoted in Clevenger, ed., *Indescribably Grand*, 70, 61, 59, 43–44, 46; Gilbert, *Whose Fair*, 28.

35. Quoted in Rydell, *All the World's a Fair,* 155.

References

Breitbart, Eric. *A World on Display: Photographs from the St. Louis World's Fair, 1904.* Albuquerque: University of New Mexico, 1997.

Buel, J. W., ed. "Types and Development of Man." In *Louisiana and the Fair: An Exposition of the World, Its People, and Their Achievements,* vol. 5. St. Louis: World's Progress Publishing Co., 1904.

Clevenger, Martha R., ed. *Indescribably Grand: Diaries and Letters from the 1904 World's Fair.* St. Louis: Missouri Historical Society Press, 1996.

Gilbert, James. *Whose Fair? Experience, Memory, and the History of the Great St. Louis Exposition.* Chicago: University of Chicago Press, 2009.

James, Elisabeth Beverly. "Gerhard Sisters, St. Louis, MO." *Bulletin of Photography* 18, no. 446 (February 23, 1916): 230.

Medak-Saltzman, Danika. "Transnational Indigenous Exchange: Rethinking Global Interactions of Indigenous Peoples at the 1904 St. Louis Exposition." *American Quarterly* 62, no. 3 (September 2010): 591–615.

Parezo, Nancy J., and Don D. Fowler. *Anthropology Goes to the Fair: The 1904 Louisiana Purchase Exposition.* Lincoln: University of Nebraska Press, 2007.

Rogen, Jessica. "Laura Miller Takes a Deep Dive to Elevate Awareness of Japanese Culture." *UMSL Daily* (blog), University of Missouri–St. Louis, March 26, 2019, https://blogs.umsl.edu/news/2019/03/26/laura-miller.

Rydell, Robert. *All the World's a Fair: Visions of Empire at American International Expositions, 1876–1916.* Chicago: University of Chicago Press, 1984.

Rydell, Robert W., John E. Findling, and Kimberly D. Pelle. *Fair America: World's Fairs in the United States.* Washington, DC: Smithsonian Institution Press, 2000.

Smith, Shawn Michelle. *Photography on the Color Line: W. E. B. DuBois, Race, and Visual Culture.* Durham: Duke University Press, 2004.

Stevens, Walter B., ed. *The Forest City: Comprising the Official Photographic Views of the Universal Exposition Held in St. Louis, 1904.* St. Louis: Thompson Publishing Company, 1904, 10.

Wexler, Laura. *Tender Violence: Domestic Visions in an Age of U.S. Imperialism.* Chapel Hill: University of North Carolina Press, 2000.

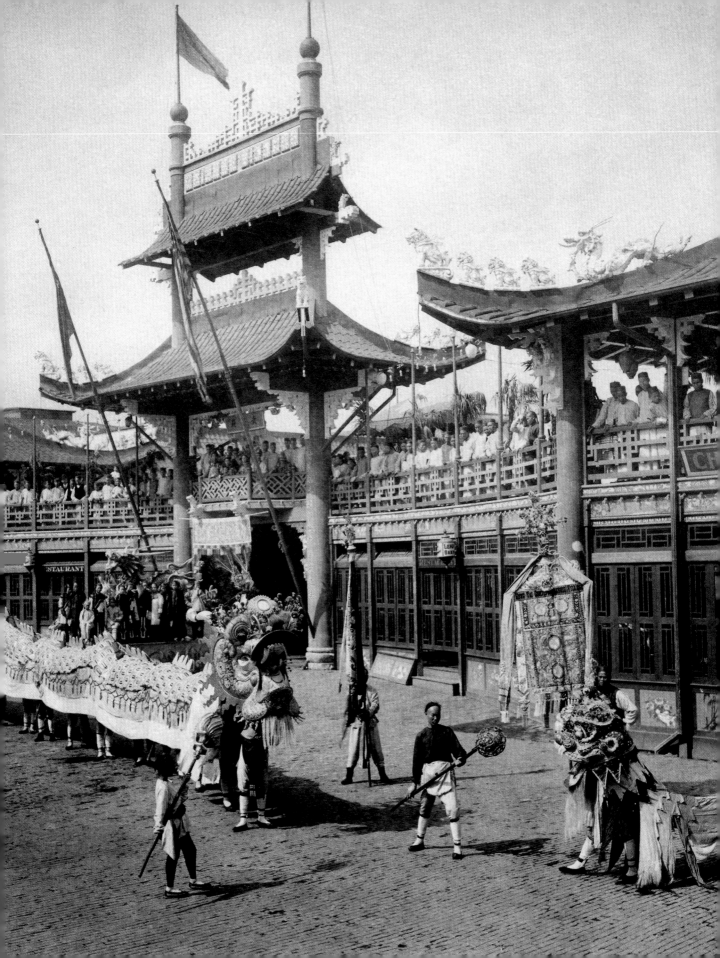

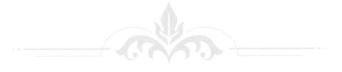

WHY SHOULD WE, THE CHINESE, MEET AT THE FAIR?

By Peter Tao

The 1904 Louisiana Purchase Exposition (LPE) celebrated the centennial of the United States' windfall land deal in 1803 that doubled the nation's size. The Missouri Territory was a substantial part of the Louisiana Purchase, and 101 years later, the LPE would be a global platform from which to boldly and proudly showcase the country's many cultural achievements, as well as its views, stature, and superiority. Hosting the 1904 World's Fair was also quite an achievement for St. Louis, then the fourth-largest city in the US, as well as an opportunity to demonstrate how it was a crucial piece of the country's success.

And what a grand production it was for St. Louis and for the nation. Transforming more than 1,000 acres of Forest Park—at the time a rural park—into the fairgrounds was a massive accomplishment that outshone every exposition before it. What a wonderful time for all people. But was it really?

There are the popular stories about the 1904 World's Fair that most everyone is familiar with, but as is often the case with large-scale endeavors, many stories have gone untold.

A Chinese celebration in front of the Chinese Village on the Pike. Photograph by Official Photographic Company, 1904. N16583.

The Louisiana Purchase Exposition had more than its share. But these important stories go far beyond the physical and economic achievements of creating such a fantasyland; they're the result of a production that took place at a certain time in a certain era, shaped by local and global influences. The expository snapshots that follow will convey some of these lesser-known stories and new insights while posing the question: *Why should we, the Chinese, meet at the Fair?*

<center>⊷▸⬥◂⊷</center>

It must be understood that during this time Chinese people, locally and nationally, were viewed unfavorably. Local newspapers frequently wrote negative and sensational stories about St. Louis's Chinatown and its residents, describing them with terms such as "almond eyes," "celestial," "chink," "Chinaman," "Chinee," "heathen," "hop slave," "Mongolian," "peculiar," "rat eaters," "slant eyes," and "yellow."

It is unclear how the local Chinese, albeit a relatively small population in 1904, interacted with the Fair, or if they did at all. Given their negative portrayal during this era, we can surmise that they must have felt internally conflicted, as evinced by many actions leading up to the Fair, such as the passage of the Clark Amendment, an amendment that was tacked on to the 1902 Mitchell-Kahn Bill, which was an extension to existing Chinese exclusion laws.

As preparations for the Fair were underway, it became clear that Chinese workers would be needed—but in the early 1900s, Chinese people were largely prohibited from being in the country. World's Fair authorities turned to Champ Clark, a member of the Missouri House of Representatives, to propose an amendment that would allow Chinese workers to be at the Fair, but only while working on the fairgrounds.[1]

This amendment prompted a 1902 story in the *St. Louis Post-Dispatch* headlined "Our Closed Door Not Lookee Nice." In it, Jeu Hon Yee, a local Chinese resident who often spoke on behalf of the Chinese community, questioned the amendment's contradiction that allowed Chinese people to work at the World's Fair even as the country had previously banned all laborers under the 1882 Chinese Exclusion Act. As Yee was a frequent spokesperson, his opinion was likely a commonly held one among St. Louis Chinese.[2]

While China was invited to participate in the 1904 World's Fair, it was an invitation that came with many strings attached. The Chinese Exclusion Act was very much in effect in 1904. Signed by President Chester A. Arthur, the act was the first federal law to ban most Chinese from being in the country—particularly laborers, who were seen as a threat to American jobs. This theme has carried through generations of debates over immigration, even to this day. However, the Fair needed Chinese laborers.

The Chinese Exclusion Act was not the first discriminatory law against Chinese people that had been passed in the United States. The Page Act had been created seven years before. It was the first federal law to ban Chinese women (and other "Orientals") from the country, under the premise that all Chinese women were promiscuous and engaged in sex work. While there's no doubt that Chinese

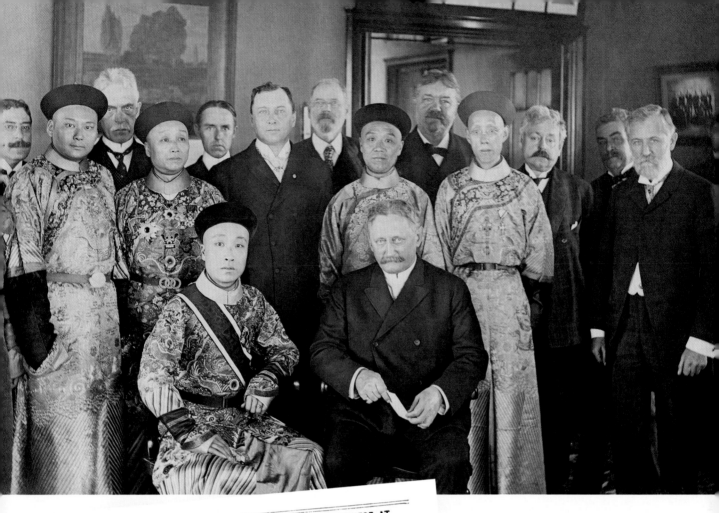

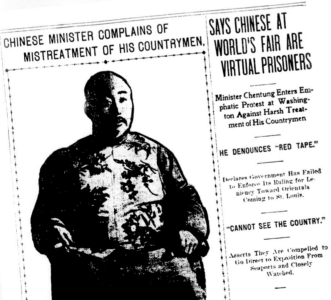

SAYS CHINESE AT WORLD'S FAIR ARE VIRTUAL PRISONERS

CHINESE MINISTER COMPLAINS OF MISTREATMENT OF HIS COUNTRYMEN.

Minister Chentung Enters Emphatic Protest at Washington Against Harsh Treatment of His Countrymen

HE DENOUNCES "RED TAPE."

Declares Government Has Failed to Enforce Its Ruling for Leniency Toward Orientals Coming to St. Louis.

"CANNOT SEE THE COUNTRY."

Asserts They Are Compelled to Go Direct to Exposition From Seaports and Closely Watched.

An official meeting among Prince Pu Lun (seated, left); Wong Kai Kah, the Chinese commissioner (directly behind the prince); and David R. Francis, World's Fair president (seated, right). Photograph by Jessie Tarbox Beals, 1904. N21286.

Coverage of Chinese mistreatment at the World's Fair in the *St. Louis Republic*, April 12, 1904.

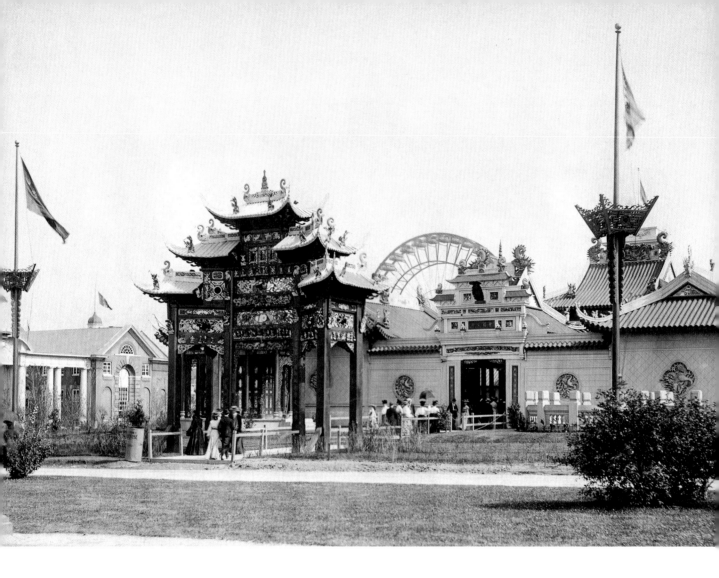

prostitutes existed, the contradiction is there was no such prejudicial law for the many other women working in the sex industry. Banning all Chinese women was a drastic measure. It should be noted that, in the early 1800s, prostitution was tolerated and encouraged on the Western frontier.

Being labeled a "banned person"—even if the ban was mostly directed toward laborers—meant that the entire Chinese population was generally viewed in a negative light. However, China was also considered a great, untapped global trade opportunity, and the LPE planners saw this as a courtship of sorts for future global trade in spite of their other views. *We welcome you, but only a part of you,* their thinking went. For its part, China was not ignorant of the situation and did not object to being at the Fair, but it understood the precarious situation it was in. China needed to feel accessible and communicative with the Western world while approaching with caution and tolerating insults.

International competitions—the Olympics, the World Cup—remain extremely popular, and they're often platforms for countries to show themselves off to the world. But they are not always an accurate representation of the country and its people, and that was also the case at the World's Fair in St. Louis. Over 60 countries participated, more than any other World's Fair up to that point, and it was the first time that many Americans were exposed to an array of unfamiliar cultures at once.

St. Louis marked China's first participation in a World's Fair. In this geopolitical theater it was a chance for the struggling Qing Dynasty, China's governing structure, to take a step forward on a global stage. It was also a time for China to demonstrate its advancements since the anti-imperialist Boxer Rebellion (1899–1901) and the Boxer Protocol. So, much like it was for St. Louis, the World's Fair was China's coming-out party and a timely marketing opportunity to show the international community who the Chinese people were. Up to now, most in the Western world thought of China as ancient, backward, insular—definitely mysterious and exotic.

Performers in the Pike's Chinese Theatre. Photograph by Official Photographic Company, 1904. N21287.

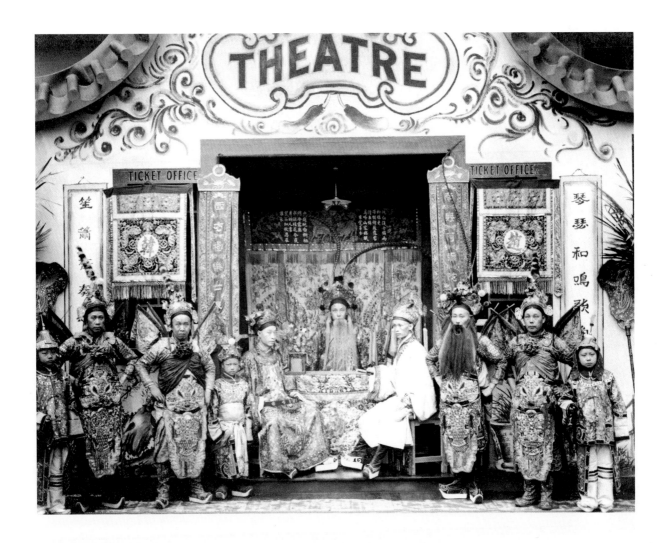

The Fair had a deliberate anthropological overlay meant to demonstrate Western superiority over other countries and cultures. White supremacy and colonialism were openly promoted, and so-called primitive peoples were held in human zoos. In an August 27, 1901, story in the *St. Louis Globe-Democrat*, William McGee, an ethnologist at the Smithsonian Institution, announced his vision for the Fair's ethnological exhibits: to showcase "barbarians and semi civilized" in a "colossal village." McGee went on to say that even primitive peoples could be domesticated, and "they make very good servants too."[3]

More recently St. Louisan Janna Añonuevo Langholz discovered that the Smithsonian had collected the brains of four Filipinos who'd been kept in the Fair's human zoo and died; their brains had been removed prior to burial. This was part of the Smithsonian's "racial brain" collection, established to research and prove racial inferiority. It was never the intention of the Fair's organizers to solely display other countries' commerce and cultural achievements. Presenting the inferior "other" was a well-curated script woven tightly into the fabric of the Fair.[4]

China's impressive showing at the World's Fair is well documented. It hosted grand exhibits at the Chinese Village, the Pike, and other buildings. But it was not as though the Chinese who were working and representing the exhibits were welcome. Some of the workers weren't even at the Fair by their own free will. The Chinese workers who were sent to build and perform were "permitted" to be there. They were not just closely watched, they were basically prisoners of the US Office of Immigration. For each worker a $500 bond was underwritten and applied to their permit into the country because of the fear that they would not return to China. Essentially, a bounty would be placed on them if there were any violations of the terms of entry. They had to return to China after the Fair closed.

There are many accounts of Chinese people being mistreated by US immigration officials when they entered through San Francisco. Some were kept on their arrival ship for up to four days, often held in jail cells before eventually being released to continue their journey to work in St. Louis. After arriving in St. Louis, workers were met by authorities who continued to track them. The same was even true for visitors who were freely admitted into the country.[5]

An account in the August 19, 1904, edition of the *Post-Dispatch,* titled "Chinamen Rounded Up Like Cattle by Inspectors," stated that upon arriving at the Wabash train station on August 18, Chinese visitors—some of whom were merchants from Hong Kong, Canton, and Peking—were "brought out one by one. Each wore a number on his breast like a prisoner and the number was called off. They were lined up with their heels on the rail of the next track." The station also had a pen enclosed by a high picket fence, presumably to corral the "visitors" and screen the Chinese from the public.[6]

While working to complete the Chinese Pavilion in March 1904, Chinese artisans were attempting to exit the fairgrounds when they were stopped. A rule at the Fair stated that no package could leave the grounds without a permit. The artisans were all carrying packages. Perhaps due to miscommunication and limited empathy for non-English speakers, the gate guardsmen asked for permits and required the men to open their packages. The men were rattled and confused by

what was being asked of them, and the guardsmen accused the men of stealing the objects in their possession.

Angry and insulted, the men took the objects and smashed them in front of the guardsmen to prove they were not stealing, and the items were of no value. As it turns out, these objects were extra pieces of art that the Chinese government had ordered the artisans to deliver to a Chinese liaison so they could be gilded and made into gifts for distinguished World's Fair guests and officials.[7]

There's another account of a Chinese man being dehumanized. Fairgoer Charles A. Ross was fascinated by the novelty of the Chinese Village—in particular the appearance of one of the workers, Yue Ting. Ting wore his hair in a "queue." The Qing dynasty forced the queue hairstyle upon men and women to assert their dominance and control. The way the Chinese dressed and wore their hair was already a visual peculiarity to Westerners, and now Fair visitors could see it in person.

Ross attempted to coerce Ting into allowing him to take some of his hair in exchange for $1 per inch. Ross relentlessly heckled the non-English-speaking Ting, who simply nodded because he did not understand what was being asked of him. When Ting turned away, Ross surprised him from behind, grabbed his hair, and crudely hacked off 2 inches. Justice came quickly as other workers in the Chinese Village surrounded Ross until police arrived. He was arrested and fined for disturbing the peace.

Given the "welcome" that Chinese visitors had received—as well as the constant surveillance, harassment, and arrests—it's difficult to imagine that local Chinese merchants would have had much of an interest in risking an appearance at the

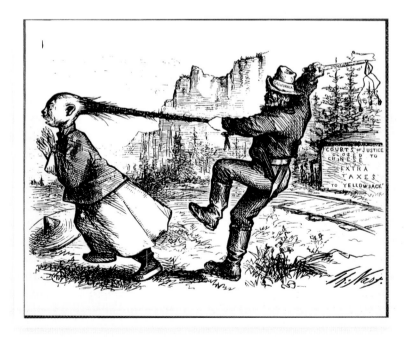

"Pacific Chivalry."
Political cartoon by Thomas Nash, published in *Harper's Weekly*, August 7, 1869.

"The Lure of the Mongols." Published in the *St. Louis Post-Dispatch*, September 1, 1907.

fairgrounds. But certain Chinese guests were always well received: royalty. Prince Pu Lun, who was in line to be emperor of China, was the country's designated representative. Locally, he was accompanied and represented by Wong Kai Kah, the Chinese commissioner to the Fair. There are numerous accounts of local representatives meeting and socializing with the prince. Although it brought a taste of home and nostalgia to some Chinese in the US, these gatherings appeared to be private events that did not take place on the World's Fair grounds.

Royalty and the elite were usually not subject to the Fair's established rules, and favoritism was the norm. In November 1904, when commissioner Wong Kai Kah happened to be on the fairgrounds, a French airship was landing at the aerodrome. Many dignitaries and Fair officials were gathered in a permitted area to view the spectacular landing, and the commissioner hoped to join them. But there was a problem: He was not on the "official" list. When he arrived at the cordoned-off gate, the guardsmen refused him entry. A nearby Fair official recognized the commissioner and told the guardsmen that it was fine to let him in, but still he

was denied. No favoritism in this case. Was this strict enforcement of the rules or perhaps discrimination? A dignified man, the commissioner did not wish to cause a scene, so he politely accepted his fate and walked away.[8]

On a somewhat lighter side, well-to-do white women were quite fascinated by the Chinese and other Asian men at the Fair. To many, this was baffling: How could women be attracted to—as a 1907 story in the *Post-Dispatch* headlined "The Lure of the Mongols" put it—"races considered intellectually and morally inferior to the white"?[9]

During one visit to St. Louis in April 1904, Prince Pu Lun's train stopped in Carlyle, Illinois, where two women on the same train jumped out of their cabin to find the prince's cabin. As the train started moving, they ran along the platform until they found him and jumped onto the cabin steps only to find the door locked. Just one month later Prince Pu Lun made a stop in Indianapolis, where, the *Indianapolis Journal* described, the prince "threw a thousand richly gowned women of Indianapolis into a fever of excitement."[10]

Occasionally white men pursued Asian women. Charles Laughrey, an agent with the US Treasury, was assigned to escort Chinese workers traveling to and from San Francisco and enforce immigration law. He fell in love with Ah Fong Wah, a Chinese actress performing at the Fair's Chinese Theatre, and eventually sneaked her away to San Francisco to wed. Pandemonium broke out among her fellow Chinese actors when she missed a performance.[11]

RAID HOP ALLEY IN SEARCH OF CELESTIAL MISSING FROM FAIR.

UNCLE SAM'S MEN INVADE MANY LAUNDRIES WITHOUT FINDING MAN WANTED.

There was consternation in Chinatown yesterday afternoon when a party of Uncle Sam's minions invaded Hop alley on a laundry-to-laundry canvass and laid the stern hands of the law on a score or more of the Chinese population. The frightened Celestials were taken completely by surprise. The Chinese were ruthlessly torn from chop suey and washtubs alike, while opium joints were visited and the denizens turned out of bunks and made to line up for inspection.

The excitement had not subsided around Hop alley last night, and Immigration Inspector Dunn has no intention of letting it subside until his agents have discovered the whereabouts of one Wong Kai, 48 years old, a "bonded" Chinaman, who disappeared from the Chinese village at the World's Fair election night. He was missing when the roll was called by the inspectors yesterday morning.

Mr. Dunn got a "cue" that Mr. Wong was in hiding along Market street. Two hours later Mr. Dunn had a dozen "cues" in his office in the Chemical building as

Proving an alibi.

the returns from the round-up. Some of the Celestials were able to produce certificates and some were not. The latter were held for further investigation. Wong was not among them. The search will continue to-day.

Coverage of the search for **48-year-old Wong Kai,** who escaped from the Fair's Chinese Village, in the *St. Louis Globe-Democrat*, November 10, 1904.

As the end of the Fair neared, officials prepared to return the Chinese to China, not unlike returning a certified package. But they also heard rumblings about a possible "great escape." November 16, 1904, was the last day that Chinese workers could "officially" remain, and Fair organizers harbored suspicions that on this evening there would be "a stampede and general escape of the Orientals." It was also feared that the Chinese Village would be set ablaze, creating a distraction that would allow for this breakout. As a result, the Chinese Village was heavily guarded and watched.[12]

The fear was so intense that for the 231 residents of the village, the ratio of Chinese to law enforcement—that is, federal agents, policemen, and fairgrounds guards—was nearly 1 to 1 by the time of their evening departure. When nightfall

"Geisha Girl Fights Men Who Come to Deport Her." Published in the *St. Louis Republic*, November 18, 1904.

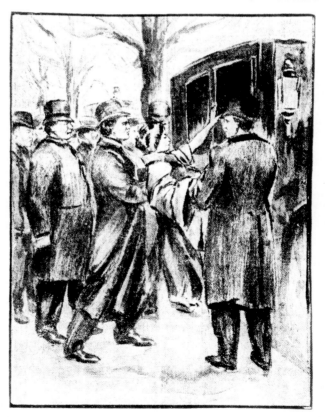

ST. LOUIS, FRIDAY MOR

GEISHA GIRL FIGHTS MEN WHO COME TO DEPORT HER.

UYEKI RESISTING EFFORTS TO PUT HER IN CARRIAGE.

WHY SHOULD WE, THE CHINESE, MEET AT THE FAIR?

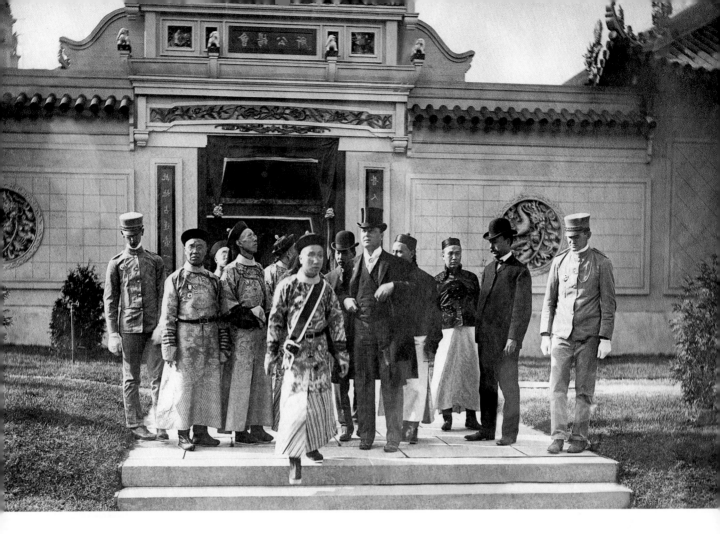

came, the residents of the Chinese Village were lined up, handcuffed in pairs, and kept in smaller groups. They were then marched to the Wabash station and put on the train bound for San Francisco. The prisoners would be loaded onto tourist-class cars, including many who were sick and should have had better accommodations. Four guards were assigned to each of the eight cars. The remaining guards traveled in the comfort of sleeping cars.[13]

There are other accounts of Asians receiving similar treatment, including 13 geishas from Japan. The *St. Louis Globe-Democrat* reported that closed carriages staffed with law enforcement arrived unannounced to deport the women. Many of the women had become accustomed to prayer after staying at the Emmaus Home throughout the Fair and knelt down in the parlor to pray, frantically clinging to Miss Harding, the home's supervisor, begging her to help them. A woman named Uyeki fought with immigration officials until they forcibly grabbed her and carried her down two flights of stairs. An artist depicted the moment she was hoisted into their waiting carriage in an illustration published in the *St. Louis Republic*.[14]

Chinese officials visiting the Chinese Pavilion. Unknown photographer, 1904. N37496.

So, what are the takeaways of the Fair and the effects it had on Chinese people locally and nationally? While the Louisiana Purchase Exposition was a magnificent production, there were many conflicts, and mistreatment of the Chinese was rampant. And yet in the years that followed the Fair, there seems to be evidence of a significant increase in new Chinese businesses in St. Louis and an increase in the arrival of Chinese college students.

Is there any correlation? Did the sacrifices of the Chinese people who came to the Fair help break down any preconceptions, stereotypes, or prejudices? Did the Fair promote a greater tolerance for Chinese people? The *Post-Dispatch*'s "Lure of the Mongols" story cited an "epidemic" of interracial marriages: Within one year, eight Chinese men and one Japanese man had escaped to East St. Louis, Illinois, to marry white society women. Missouri was not a welcoming state for interracial marriages, and in 1909 it passed a miscegenation law that prohibited the marriage of white people to "Mongolians." This law would stay in effect for 58 years, until the landmark US Supreme Court case *Loving vs. Virginia*.

A quote in the *Post-Dispatch* story dispels the idea that it was simply the allure of the exotic that brought these couples together. "Why do we marry Chinamen?" asked the wife of an Asian man. "Because they are good to us."[15]

As with any event that receives global news coverage, positive or negative, the 1904 World's Fair influenced opinions. And while the United States did not really want Chinese people here, under the purported reason of labor protection, the Fair ultimately made some people think more deeply about the broader world. The next year brought renewed debates and evaluation of exclusion laws. Wong Kai Kah became more outspoken about the unfair practices and passport enforcement of the US Office of Immigration. He noted that the Chinese were becoming "great travelers," and that in places such as Germany and England, they were received with "open arms."

Also in 1905 the Chinese stood up to the Chinese Exclusion Act and the continued violence and discrimination Chinese people faced in San Francisco and Boston by boycotting American goods and services in China. St. Louis Chinese were sympathetic to this movement as well. Recognizing that such turmoil was not good for international relations and commerce—particularly the untapped potential of the growing Chinese market—President Theodore Roosevelt would demand immigration reform and the fairer enforcement of laws.

While some progress was made toward better treatment of Chinese people in the years after the 1904 World's Fair, it was short lived. Discrimination remained deeply embedded in the United States. Even though the 1882 Chinese Exclusion Act was amended numerous times, it stayed in effect for 82 years. It was not until the passing of the Immigration and Nationality Act of 1965, signed by President Lyndon B. Johnson, that the Chinese would finally be "included" under the same rights and protections as other immigrants.

Our immigrant colonists had a vision, reinforced by our immigrant founding fathers, that "all men are created equal." More than 100 years after the World's Fair we continue to witness the United States and its citizens grappling with its history as a nation of immigrants, a country that once embraced the concept to "give me

MAKE MISTAKE IN ARREST OF CHINAMAN

MAN IN CUSTODY PROVES TO BE SERVANT OF DIPLOMAT.

Immigration inspectors made another raid on Hop alley yesterday, arresting Leung Nong on suspicion of violating the Chinese exclusion-act. His case will be heard by Commissioner Babbitt, next Thursday. Last Thursday five Chinese were arrested by Inspector A. C. Ridgway. They were Jeu Gnong, Mon Lat, Ng Mun Hai, Lew Ting Suey and Yip Kon of Washington, D. C.

Not long after Yip Kon was captured a Chinaman rushed into the inspector's office with papers in his hands and shout-

Coverage of the mistaken arrest of Yip Kon, who was apprehended on suspicion of violating the Chinese Exclusion Act, in the *St. Louis Globe-Democrat*, November 12, 1904.

your tired, your poor." Immigrants, old and new, represent the United States' greatest strengths. They are often tireless leaders whose hands have worked on some of the world's most important discoveries, inventions, cures, and businesses.

We live in a time of globalization and global mobility, where studying or living abroad and being an expat is often viewed as a positive—and even envious—position for many Americans. Why is it that this view is not reciprocated for the foreign-born expat or the transient who comes to live and work in the US? Are the standards that we apply to these visitors what we'd wish upon ourselves when we are in other countries?

Let us rethink our views on the foreign born and fix our broken immigration system, so we can benefit from immigrants' contributions and avoid another Chinese Exclusion Act.

Peter Tao is an architect by profession and a community leader in St. Louis. A second-generation Chinese American, Tao was born in St. Louis to parents who immigrated to St. Louis in 1947. He was one of the founders of and catalysts for the Missouri Historical Society's Chinese American Collecting Initiative and currently serves as the chair of the Chinese American Advisory Group, where he researches and writes as an amateur public historian.

Endnotes

1. "Mitchell-Kahn Bill Amended," *St. Louis Republic,* March 24, 1902.

2. "Our Closed Door Not Lookee Nice," *St. Louis Post-Dispatch*, March 24, 1902.

3. "All Tribes of Earth," *St. Louis Globe-Democrat,* August 28, 1901.

4. Joy Sharon Yi, "How the *Post* Reported on the Smithsonian's Human Remains," *The Collection* video, *Washington Post*, August 17, 2023.

5. "Officials Enter Denial," *Evening Republic*, April 14, 1904.

6. "Chinese Rounded Up Like Cattle," *St. Louis Post-Dispatch*, August 19, 1904.

7. "Chinese Smashed Wooden Images," *St. Louis Post-Dispatch*, May 21, 1904.

8. "Francois's Big Airship Appears," *St. Louis Republic*, November 15, 1904.

9. "The Lure of the Mongols," *St. Louis Post-Dispatch*, September 1, 1907.

10. "Throngs of Women Wait for Imperial Highness to Finish His Royal Nap," *Indianapolis Journal*, May 21, 1904.

11. "Geisha Girl Fights Men Who Come to Deport Her," *St. Louis Republic,* November 18, 1904.

12. "Chinese Village Closely Guarded," *St. Louis Republic*, November 17, 1904.

13. "Geisha Girls and Chinese Depart Under Heavy Guard." *St. Louis Republic*, November 18, 1904.

14. "Geisha Girl Fights Men," *St. Louis Republic.*

15. "The Lure of the Mongols," *St. Louis Post-Dispatch.*

References

Magazines, various years and articles: *Confluence, Gateway Heritage, New Inquiry.*

Newspapers, various years and articles: *Indianapolis Journal, St. Louis Globe-Democrat, St. Louis Post-Dispatch, St. Louis Republic, Washington Times.*

Yi, Joy Sharon. "How the *Post* Reported on the Smithsonian's Human Remains." *The Collection* video, *Washington Post*, August 17, 2023.

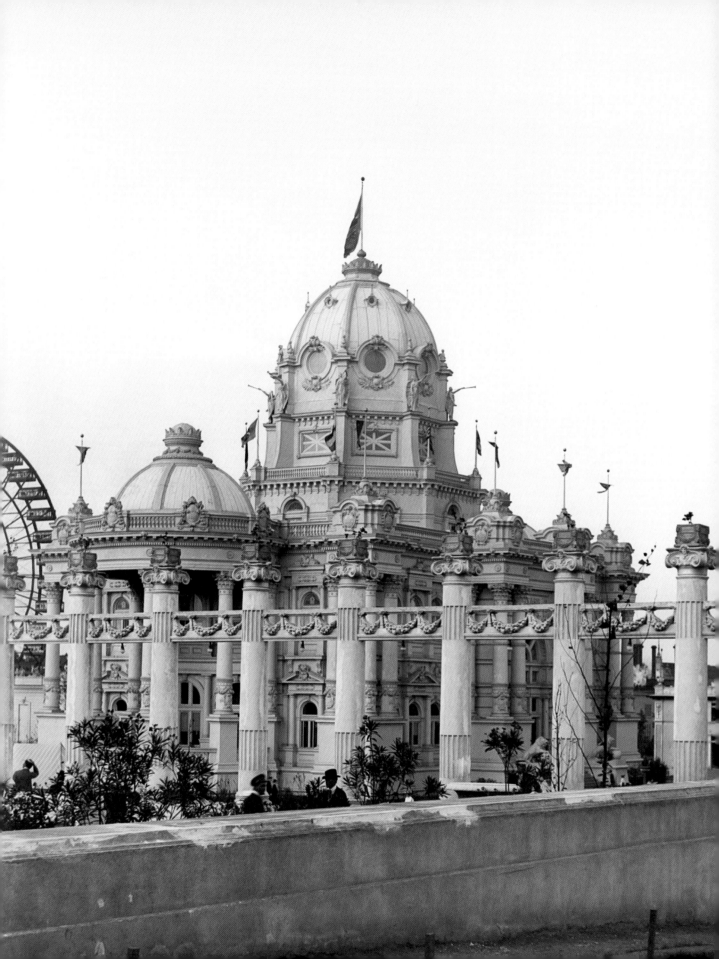

IDENTITY, POLITICS
How Nations Used the 1904 World's Fair to Shape Their Global Image

By Kristie Lein

As part of its 1904 World's Fair exhibit, Japan constructed a fully functioning silkworm nursery and factory. Brazil brought more than 216,000 pounds of coffee and offered it to fairgoers for free. Uruguay had a small display of *carne líquida*, liquid meat, made by a company based in Montevideo. While the items that nations chose to highlight in their exhibits varied greatly, having any sort of presence at the 1904 World's Fair made a significant global statement.

The Book of the Fair declared that "nearly all foreign countries of any consequence were represented at the [Louisiana Purchase Exposition]." *International Studio* magazine went even further, calling the Fair a "competition of the nations," a largely accurate description. The more than 60 countries that came to St. Louis under the guise of global unity leveraged their appearances to set themselves apart, reshape long-held impressions, or cultivate new economic pathways.

Although certain aspects of the World's Fair were designed to reinforce the belief that white European ideals were the peak of intelligence and culture, some countries' exhibits

The Brazilian Pavilion was often referred to as "the jewel of the Fair." Photograph by Official Photographic Company, 1904. P0166-544-4g.

were so effectively assembled that they managed to surprise and delight. The authors of the 1905 book *History of the Louisiana Purchase Exposition* acknowledged that displays from Central and South American nations in particular challenged their preconceived notions:

> Much as we expected from those famous mothers of literature, science, art and skilful [*sic*] craftsmanship, Germany, France, Belgium, the United Kingdom, Italy and Austria-Hungary, their exhibits showed them all still pressing onward with unabated energy and ambition to new triumphs—still determined to lead the world in cultivation of both the useful and the beautiful. But what pleased us Western World people most, if it did not most impress the European mind, was the surprising revelation of the vast resources, progress and capabilities of British America, Mexico, Argentine [Republic], Brazil and Central America. People supposed to be inveterately addicted to weekly revolutions as a pastime, surprised the world at this Exposition with exhibits showing the finest fruits of civil order, industrial development, culture and devotion to the arts of peace. . . . A few years ago one thought of Buenos Aires as a small city near the mouth of the River Plate, where tramp vessels occasionally stopped for a cargo or hides and horns. With more than a million inhabitants now, its thirty-five million dollar port and a gigantic commerce, it is one of the world's most progressive and beautiful cities.[1]

Many countries sought to elevate their profile by accentuating their cultural treasures, natural resources, and scientific advancements. Others positioned *themselves* as the product and encouraged outsiders to do business in their country or even move there permanently. This was especially true of places that were colonies of Western nations, including Rhodesia (today Zimbabwe), then under the administration of the British South Africa Company. Photographs on exhibit in the Palace of Agriculture portrayed the region's forests, plains, mountains, and valleys as ripe for business. Its precious metals—gold, nickel, and copper—were also promoted, along with Rhodesia's extensive railway system, ready to move these and other resources out of the territory. Showcasing these assets was intended to market Rhodesia as "a white man's country, with climate, products, and conditions favorable to the development of the white man's civilization."[2]

New Zealand similarly used its World's Fair appearance to demonstrate the "progress" that the Māori, the country's Indigenous people, had made since Europeans began settling there in 1840: "On the prior date the Maori [*sic*] was a savage, clever and enterprising, but ferocious and cruel, and a cannibal. . . . Contact with a highly civilized community has diverted the natural intelligence of the Maori to useful channels, whilst Christianity has developed the best instincts of a fine race of people."[3] New Zealand's exhibits also appealed to outdoorsmen, displaying photographs and paintings of forests, lakes, and streams, as well as the many species of fish and animals that could be hunted there.

Ostensibly the 1904 World's Fair was meant to unite disparate people from all over the world, to illuminate the best of humanity and share new ideas. But a thrum of one-upmanship ran just below the surface. Almost every country built

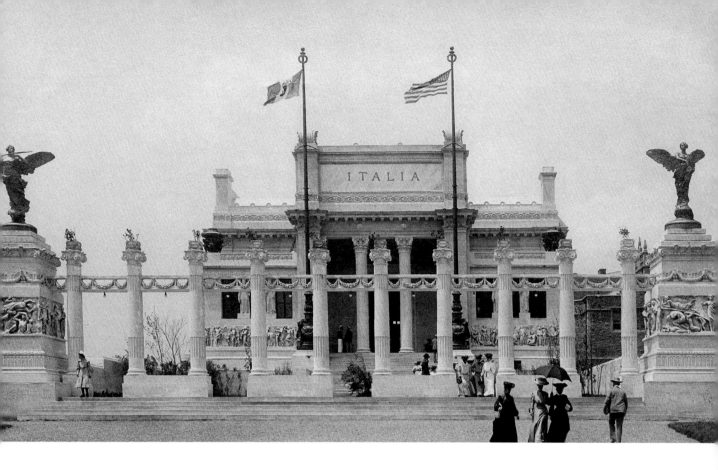

a palace or pavilion to serve as its physical representation at the Fair, and many of them went big. Surrounded by 8 acres of gardens brimming with lakes, fountains, statues, and trees, the French Pavilion replicated the Grand Trianon of Versailles. The Italian National Pavilion was modeled after the ancient marble villas favored by Roman emperors; to reach it, visitors had to climb a massive set of stairs that measured 90 feet wide. The Argentine Pavilion was a scaled-down version of Casa Rosada—the Pink Palace—where Argentina's presidents live.

But other countries took a different tack. The Canada Pavilion was designed to feel like an inviting two-story home. Fairgoers were drawn to its charming gardens and broad verandas, where they could stop to rest in the shade and eat. The Canadian delegation then took its warm welcome one step further: Immigration officers stationed at the pavilion's exits distributed pamphlets to visitors that encouraged them to move to Canada permanently. Canada's openness toward immigration is a tradition the country continues to uphold: Immigrants make up nearly 25 percent of its population, and thanks to its access to basic rights, healthcare, and education, Canada consistently ranks among the best places for immigrants to live. Among citizens from 140 nations, Canadians had the most favorable opinion of immigrants on Gallup's 2020 Migrant Acceptance Index, even as people worldwide became less accepting of them.[4]

For certain nations, having any presence at the Fair at all sent an unmistakable message. Austria nearly passed on the 1904 World's Fair until it was revealed that the Ottoman Empire—the Austro-Hungarian Empire's centuries-long

The Italian National Pavilion, modeled after the ancient marble villas favored by Roman emperors. Photograph by Official Photographic Company, 1904. P0166-06614.

Fairgoers appreciated the more understated, welcoming nature of the Canada Pavilion. Photograph by Louisiana Purchase Exposition Co., 1904. P0166-00082.

This illustration, *Types and Development of Man*, ranked humans from the most to least advanced, with "Americo-European" at the top and "Prehistoric Man" at the bottom. Frontispiece from *Louisiana and the Fair*, 1904. GRA00633.

adversary—would not be participating. The Austrian government then scrambled to make a name for itself, even though delayed construction of its palace meant it wouldn't open until two months after the Fair itself did. Of the Austrian Pavilion, *Brush and Pencil* noted, "unlike other national historical reproductions at the Fair, such as the German 'Charlottenburg' or the French 'Trianon,' the Austrian home was quite modern. It exemplified the new European tendency in art and decoration which breaks with tradition and aims at applying art to every sphere of practical existence of the present day."

Germany was likewise reluctant to take part in the Fair, but German Americans pushed for participation as a way to bolster their homeland's image. Ultimately the Second Reich agreed and set out to claim superiority in culture, education, and the arts. Its efforts succeeded mightily and found a particularly enthusiastic fan in World's Fair president David Francis, who wrote, "Germany overwhelmed the estimate of the world by an incomparable display, especially of its industrial art products, in variety and superiority that were a revelation."[5] Berliner Bruno Möhring designed the country's entrance hall in the Palace of Varied Industries, which conveyed an "overwhelming impression of German imperialism, with imposing eagles flanked by a colonnade leading up to an entry that echoes the form of a triumphal arch," motifs that even today remain closely associated with Germany.[6] The country spent $690,000 (nearly $24 million in 2024) on its participation in the Fair, more than any other foreign nation.

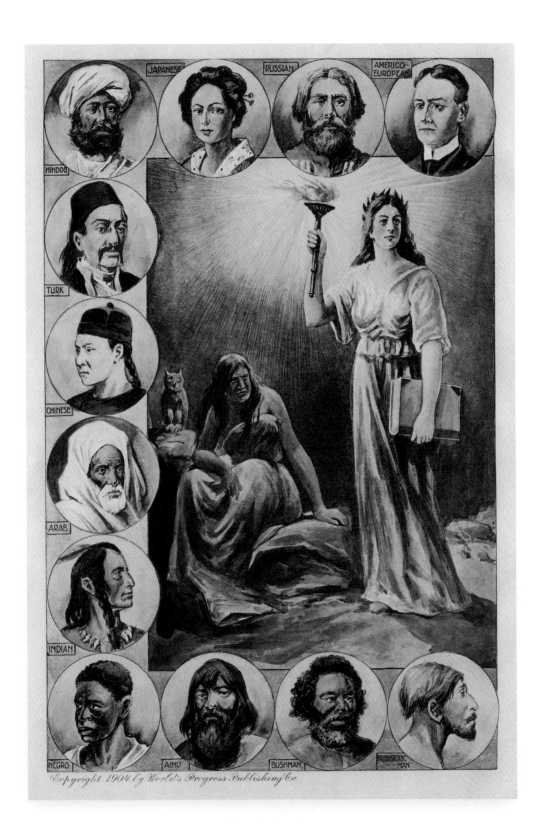

IDENTITY, POLITICS

One of two tea palaces
inside the Japanese gar-
dens. Photograph by F. J.
Koster, 1904. N15576.

Even as countries worked hard to carefully curate their identities, ethnic groups had already been slotted into a racial hierarchy for the Fair's purposes. The frontispiece of the 1904 book *Louisiana and the Fair: An Exposition of the World, Its People, and Their Achievements* ranked "Americo-Europeans" as the most superior race, followed by "Russian," "Japanese," "Hindoo," "Turk," "Chinese," "Arab," "Indian," "Negro," "Ainu," "Bushman," and finally "Prehistoric Man." An accompanying caption explained that the scale was "an excellent specially prepared drawing which very accurately illustrates, as nearly as the science of ethnology is about to do, the characteristic types of mankind arranged in a progressive order of development from primitive or prehistoric man to the highest example of modern civilization."[7] The Smithsonian Institution's William McGee, the Fair's chief of anthropology who had been called "perhaps the greatest living authority on the subject," wrote the book's introduction, expanding upon the concept of ethnology and further lending the scale a sense of scientific legitimacy.

Arguably no country at the Fair was more invested in setting itself apart than Japan. As an Eastern nation, Japan thought it crucial to take part in this Western event and went to great lengths to present itself as a modern society that was distinct from China and especially from the Ainu, people indigenous to northern

"Ainu House and People."
Photograph by Jessie
Tarbox Beals, 1904.
P0166-16663.

Japan, who ranked just ahead of "Prehistoric Man" on the evolutionary scale. Japan spent some $631,000 (about $22 million in 2024) on its presence at the Fair—a sum second only to Germany's expenditures. The country even appointed its own commissioner, Seiichi Tejima, who helped steer the direction of its exhibits and the stories they told.[8] In the early 1900s, Japan ruled Formosa (today Taiwan), and Formosa's exhibit was displayed inside one belonging to Japan—an unmistakable message that Formosa was merely a colony of a much more powerful nation.[9] In marked contrast, several Eastern nations' exhibits were simply grouped together under the banner "Mysterious Asia."

Japan's footprint stretched well beyond its already extraordinary Imperial Japanese Pavilion, which was set within a picturesque Japanese garden boasting cascades and waterfalls, lily-pad lakes, statues, trees, flowers, and two teahouses. The country also hosted Fair Japan along the Pike, which featured cafés, shops, and venues that staged Kabuki performances. While all aspects of Fair Japan were touted as traditional, they were specifically crafted to impress and appeal to American audiences. This was best embodied in the Fair's "replica" of Japan's Nikkō Gate, a Shinto shrine first constructed in the early 1600s. Even David Francis called it "a picture of real Japan." It wasn't—it was bigger, brighter, and much more elaborate than the original. (Evidently most fairgoers did not notice or care that this replica of a centuries-old shrine had carpet-covered floors.) Even so, it was widely considered to be among the Fair's most beautiful structures.

Impressive as the Nikkō Gate was, accuracy notwithstanding, Japan's mere presence at the Fair—and Russia's absence from it—signified something much more important. The Russo–Japanese War had begun just a few months before the Fair opened. Save for a few displays on the Pike and in the Palace of Fine Arts, Russia did not have an official representation at the World's Fair. For all of Russia's purported strength, its glaring absence in St. Louis led some to wonder how it could be a formidable power yet was unable to concurrently fight a war and represent itself on the world's biggest stage. Even worse for Russia, the fairgrounds that had been set aside for its exhibits were auctioned off, and Japan went on to claim large portions of them for its displays instead. Although its participation was expensive, Japan used the Fair as a "defensive measure to maintain a strong national identity for an international audience" and to further its mission "to be seen as a nation that could stand with the giants and even succeed them."[10]

The connotation of Russia's weak showing in St. Louis wasn't lost on fairgoers. In his *Book of the Fair*, Marshall Everett praises a Japanese artist's intricate work in creating a stunning vase, then draws a direct line from this talent to proficiency on the battlefield, writing that if the artist who made the vase were to go to war against Russia, "he [would] put himself to warfare with equal devotion."[11]

St. Louis, the federal government, and individual and corporate stockholders poured $15 million (about $518.5 million in 2024) into the Louisiana Purchase Exposition, determined to show the city and the country in the best possible light. But US investors were hardly alone in this ambition. In spending more money by far than all other foreign nations to stage their spectacular exhibits, Germany and Japan made at least one American reporter pause and contemplate the United States'

Entrance to Fair Japan on the Pike, a "replica" of the Nikkō Gate. Photograph by Jessie Tarbox Beals, 1904. N20740.

own place in the global hierarchy, as well as its future: "first surprise; then profound astonishment; then mortification: this describes the feelings which developed as I made my progress throughout the Exhibition, everywhere Germany and Japan displaying a superiority for which I confess; I was in no way prepared."[12]

In using the Fair to shape global opinions, seemingly no two countries did it better.

Missouri Historical Society Editor Kristie Lein is a St. Louis native who has worked in local media for more than two decades. She has edited numerous magazines and books—including this one—for MHS and has contributed research and content to the new 1904 World's Fair exhibit at the Missouri History Museum.

Endnotes

1. Mark Bennitt et al., eds., *History of the Louisiana Purchase Exposition* (St. Louis: Universal Exposition, 1905), 190.

2. Ibid., 318.

3. Ibid., 314.

4. Neli Esipova et al., "World Grows Less Accepting of Migrants," *Gallup*, September 23, 2020, https://news.gallup.com/poll/320678/world-grows-less-accepting-migrants.aspx.

5. David R. Francis, *The Universal Exposition of 1904* (St. Louis: Universal Exposition, 1905), 315.

6. Aurora Wilson McClain, "Meeting in St. Louis: American Encounters with Nascent European Modernisms at the 1904 Louisiana Purchase Exposition" (master's thesis, University of Texas at Austin, 2015), 29, https://repositories.lib.utexas.edu/items/53037b71-455a-4f66-a745-4101c007d165.

7. James W. Buel, ed., *Louisiana and the Fair: An Exposition of the World, Its People, and Their Achievements* (St. Louis: World's Progress, 1904), 4.

8. Emily Stroble, "Japan Made for America: The Image and Influence of Japan on the 1904 World's Fair" (master's thesis, University of Arizona, 2020), 68, https://repository.arizona.edu/handle/10150/642042.

9. Ibid., 54.

10. Ibid., 77.

11. Marshall Everett, *The Book of the Fair: The Greatest Exposition the World Has Ever Seen; Photographed and Explained; A Panorama of the St. Louis Exposition* (Philadelphia: P. W. Ziegler, 1904), 371.

12. John Brisben Walker, "At the World's Fair of 1904," *The Cosmopolitan* 37, no. 5 (September 1904).

References

Bennitt, Mark, and Frank Parker Stockbridge, eds. *History of the Louisiana Purchase Exposition*. St. Louis: Universal Exposition, 1905.

Buel, James W., ed. *Louisiana and the Fair: An Exposition of the World, Its People, and Their Achievements*. St. Louis: World's Progress, 1904.

Esipova, Neli, Julie Ray, and Anita Pugliese. "World Grows Less Accepting of Migrants." *Gallup*, September 23, 2020. https://news.gallup.com/poll/320678/world-grows-less-accepting-migrants.aspx.

Everett, Marshall. *The Book of the Fair: The Greatest Exposition the World Has Ever Seen; Photographed and Explained; A Panorama of the St. Louis Exposition*. Philadelphia: P. W. Ziegler, 1904.

Francis, David R. *The Universal Exposition of 1904*. St. Louis: Universal Exposition, 1905.

McClain, Aurora Wilson. "Meeting in St. Louis: American Encounters with Nascent European Modernisms at the 1904 Louisiana Purchase Exposition." Master's thesis, University of Texas at Austin, 2015. https://repositories.lib.utexas.edu/items/53037b71-455a-4f66-a745-4101c007d165.

Stroble, Emily. "Japan Made for America: The Image and Influence of Japan on the 1904 World's Fair." Master's thesis, University of Arizona, 2020. https://repository.arizona.edu/handle/10150/642042.

Walker, John Brisben. "At the World's Fair of 1904." *The Cosmopolitan* 37, no. 5 (September 1904).

NATIONAL ASSOCIATION OF COLORED WOMEN'S CLUBS

LIFTING AS WE CLIMB

THROUGH A COLORED LENS

A Stand for Justice at the 1904 World's Fair

By Linda M. Nance and
Dr. Arthelda Busch Williams

There is no question the World's Fair held in St. Louis in 1904 was a grand affair. It was an opportunity to bring people of different backgrounds together to learn about the newest technologies and advancements in many fields. Associations, organizations, clubs, committees, curious individuals, and nations large and small excitedly made plans to participate in or come see the awe-inspiring event.

David R. Francis, the Fair's chief executive and past mayor of the city of St. Louis, governor of the state of Missouri, and US secretary of the Interior, wanted people to know that human history had reached its "apotheosis."[1] The overarching focus of the 1904 World's Fair was to boldly demonstrate to the world—with anthropological "proof"—the superiority and power of the white race. Anthropologist William McGee, a leading scientist of the early 1900s, assisted Franz Boas, head of the Fair's Anthropology Department, in

The 21st-century logo of the National Association of Colored Women's Clubs. Courtesy of the National Association of Colored Women's Clubs.

promoting these ideals. But while there were wonders to behold at every turn, there were also racist exhibits, such as the largest human zoo on record.[2]

Not much is spoken about the rampant exploitation of human beings during the 1904 World's Fair. The presentation of living exhibitions went beyond a mere fascination with different cultures and displays of people with unusual abilities or features. St. Louis's human displays were much larger than at previous Fairs. Because Fair management was intent on showing the strength of American imperialism, large fenced-in areas, whole villages, and reservations throughout the fairgrounds displayed people from around the world in their "natural habitats," much like a zoo. The Indigenous peoples on display were used as examples of the most primitive societies on the evolutionary spectrum, while the white Western cultures, seen in the opulent surroundings of the Fair, were displayed as the best and brightest in manufacturing, technology, and science. The message of supremacy was clear, and unadulterated racism was pervasive.

While fairgoers were focusing their attention on spectacular buildings, inventions, and anthropological exhibits, an equally spectacular event was taking place during the Fair. The first and most powerful nationally organized group of African American women in the United States, the National Association of Colored Women (NACW), convened their fourth biennial convention in St. Louis in July 1904. The group met in the Central Baptist Church at 22nd and Morgan streets and focused on matters affecting their entire race. Each woman was a prominent leader in her own state or community and represented a broad spectrum of accomplishment—educators, lawyers, journalists, physicians, and entrepreneurs as well as housewives and young women who were bound together by their common interest in advancing their race. The NACW had been organized nationally less than a decade earlier, in 1896. The organization had become a major force among all Black women in the country: According to national organizer Elizabeth Lindsay Davis, there were 15,000 members representing 31 states by 1902.[3]

Although the Emancipation Proclamation and the 13th Amendment had outlawed slavery more than three decades earlier, these acts also created an impossible economic position for African Americans, devoid of any viable pathways to economic security. To fill this void for Black families, women began to mobilize, sharing their education, experience, and resources and organizing themselves as part of the women's club movement. The focus of Black women's clubs was always on improving the lives of other African Americans who were lacking the necessities to thrive as free citizens. Clubs also provided opportunities for women to enjoy the camaraderie of others who shared similar interests and goals for personal growth. In fact, the motto of the NACW in 1896 was "Lifting as We Climb," a theme that continues to guide the efforts of the organization today.

Members of the NACW had come to St. Louis in 1904 to learn from the leaders in their fields, to collaborate, and to develop strategies for matters related to racial uplift. The organization's leaders and members were widely known and

National Association of Colored Women's Clubs head-quarters located at 1601 R Street NW in Washington, DC. Photograph by AgnosticPreachersKid, CC BY-SA 4.0, 2020. Wikimedia Commons.

Banner with National Association of Women's Club's motto, 1910. Collection of the Smithsonian National Museum of African American History and Culture. Wikimedia Commons.

respected as accomplished women. The national president, Josephine Silone Yates, was the first female professor and chair of the science department at Lincoln Institute in Jefferson City, Missouri (now known as Lincoln University).[4] Other notable women who were present included Josephine St. Pierre Ruffin, who had used her national newspaper, the *Woman's Era*, to mobilize hundreds of women to attend the founding meeting of the NACW in Washington, DC, in 1896. Margaret Murray Washington, professor of women's studies at the Tuskegee Institute and wife of Booker T. Washington, was there, as well as journalist and Lynch Law advocate Ida B. Wells-Barnett and Harriet Tubman, one of the most highly respected African American women of the era. Local members including organizer Marie L. Harrison, president of the St. Louis Association of Colored Women's Clubs; NACW Missouri State President Susan P. Vashon, an accomplished educator, abolitionist, and integral part of the Underground Railroad; and others ensured hospitality for all members and attendees at the convention.

The NACW had changed the year of its fourth biennial convention to coincide with the 1904 World's Fair in St. Louis, creating an added incentive for members to attend the convention. It was held from July 11 to 16, 1904.[5] The club's presence during the Fair was of dual significance: The members could view the exhibits, and the presence of these dignified, accomplished women at the Fair would communicate to visitors a visible representation of the upward mobility of the race.

Arrangements were made to hold the meeting of the NACW on the fairgrounds. However, when a small delegation of members of the NACW visited the Fair, they experienced an atmosphere of racism in stark contrast to the one of hospitality extended to Black visitors to the 1900 World's Fair in Paris. In Paris, fairgoers could view an exhibit entitled *The American Negro*, curated by historian, activist, and professor Dr. W. E. B. DuBois with the assistance of lawyer and educator Thomas Junius Calloway. The exhibit included more than 350 photographs of upwardly mobile African Americans engaging in a wide range of activities that demonstrated the progress of the race. Photographs of physicians, dentists, dressmakers, scientists, entrepreneurs, and students at Howard and Harvard universities were depicted in the exhibit. In addition, research on the social and economic progress of African Americans was displayed on charts and graphs. The award-winning display served to combat some of the stereotypical beliefs about people of the African American race.[6] But in St. Louis, there were no such displays.

Plans to celebrate the advances of Black people at the St. Louis World's Fair had been canceled, and an earlier invitation extended to Booker T. Washington to speak at the Fair was rescinded.[7] An exhibit called the Old Plantation was the only representation of African Americans offered at the Fair. There, actors held fake religious revivals, sang songs, and tended gardens for the enjoyment of white fairgoers.[8] With the exception of Scott Joplin and a few vendors, African Americans

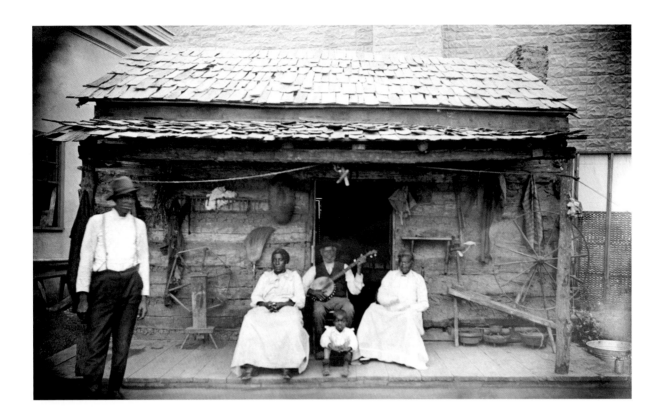

At the Old Plantation attraction on the Pike—the only representation of African Americans at the Fair—Black actors staged fake religious revivals and tended gardens for the entertainment of fairgoers. Unknown photographer, 1904. N28658.

Josephine Silone Yates, president of the NACW during the 1904 World's Fair. Photograph by the New Photographic Art Company, Washington, DC, ca. 1885. Library of Congress, Prints and Photographs Division.

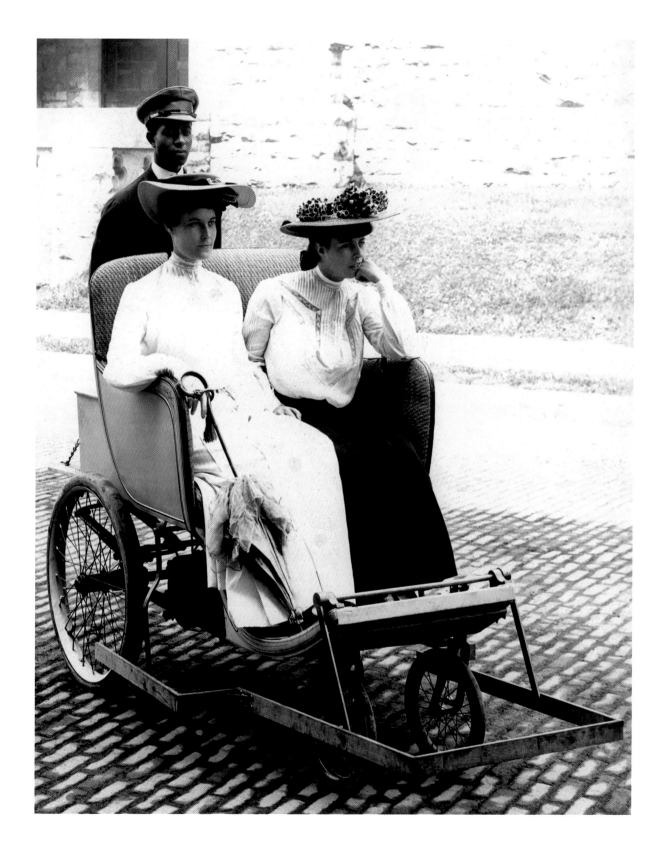

THROUGH A COLORED LENS

were only observed at the Fair as laborers in menial service jobs such as human cabs. To test that observation, Hallie Q. Brown, a college graduate and NACW member, applied for employment on the Pike and was immediately denied, although she was no doubt qualified to do the job. Despite the extremely hot day, Brown and Margaret Murray Washington were denied the opportunity to share shade or get cool drinks from the same water stations as white women nearby. Blatant displays of racism abounded. All of the restaurants on the fairgrounds were segregated,[9] and the women witnessed the exploitation of other Indigenous people of color who had been put on display.

A very different story was unfolding on a world stage. The first president of the NACW, Mary Church Terrell, was in Berlin, Germany, addressing the International Congress of Women as a representative of African American women with a speech entitled "The Progress of the Colored Women of the United States." The demand was such that the speech was delivered in German, French, and English.[10] No doubt hearing her speech in the United States—specifically at the World's Fair in St. Louis—would have easily dispelled some of the widely held stereotypical beliefs about African American women at that time.

Two women in a tandem roller chair wheeled by a uniformed Black man at the 1904 World's Fair. African Americans could only find menial service jobs at the Fair. Unknown photographer, 1904. N21644.

Mary Church Terrell, one of the founders of the National Association of Colored Women. Unknown photographer, 1880–1900. Library of Congress, Prints and Photographs Division.

LINDA M. NANCE AND DR. ARTHELDA BUSCH WILLIAMS

St. Paul Church, at Lawton and Leffingwell avenues in Mill Creek Valley, was first AME church west of the Mississippi River and home to St. Louis's largest African American congregation. The NACW held its annual meeting there after deciding to boycott the Fair. Photograph by William G. Swekosky, 1962. N46587.

When clubwomen who had visited the Fair returned to the general session, their findings were presented, and two courses of action were recommended. The first was to boycott the Fair, publicizing the move widely in local newspapers and across the country. There was to be no confusion about the conditions that prompted the action to boycott the Fair. The second action was to move the meeting originally scheduled to take place on the grounds of the Fair. Upon the acceptance of both recommendations, swift and deliberate action was taken. The meeting was moved to the St. Paul African Methodist Episcopal (AME) Church at Lawton and Leffingwell avenues. Shortly thereafter, a carefully crafted newspaper article was submitted for publication announcing both the delegation's refusal to hold their meeting on the fairgrounds and the bold stand to boycott the 1904 World's Fair. The published statement read:

> It having come to our knowledge that certain of our race have been refused refreshments and other privileges at the World's Fair accorded every other people, simply on the ground of color, the association, in convention assembled, passed a resolution to withdraw the decision to hold a session at the World's Fair grounds July 13, 1904.[11]

The article also included statements from Josephine Silone Yates's presidential address describing achievements of the NACW club women over the recent two-year period and their local and national plans for the organization's future.

Many of the statements in her address reiterated the 1900 Census and heartily reflected the economic advancements of African Americans since emancipation. According to the *St. Louis Palladium*, Mrs. Silone Yates shared with her listeners that since 1865, African Americans had acquired homes and farmlands valued at some $750 million. Their personal wealth had grown to $170 million, and they had collectively purchased 1.5 million properties. They had raised $11 million for educational purposes.[12]

During the conference, officials from various communities across the country presented reports detailing important work to improve conditions for women, children, families, and communities at large. Reports were presented by Cornelia Bowen of Waugh, Alabama, on domestic science; Mrs. Selena Gray of Chicago on mothers' clubs; Mrs. Susan P. Vashon of St. Louis on kindergartens; Mrs. Hattie Campbell of St. Louis on businesswomen; Mrs. M. L. Crosthwaite of Kansas City, Missouri, on professional women; Miss Hallie Quinn Brown of Wilberforce, Ohio, on rescue work; Mrs. Alice P. Perry of Atlanta, Georgia, on art; Mrs. Lottie Jackson Wilson

Even though she was a college graduate and well qualified to work, activist **Hallie Q. Brown was denied employment on the Pike**—one of many acts of discrimination that people of color faced at the Fair. Photograph by F. S. Biddle, ca. 1875–1888. Library of Congress, Prints and Photographs Division.

Margaret Murray Washington was a professor of women's studies at the Tuskegee Institute. Fair organizers had rescinded an invitation to her husband, Booker T. Washington, to speak at the World's Fair in St. Louis, and she was denied access to refreshments and even shade. Photograph by C. M. Battey, Tuskegee Institute, Alabama, ca. 1917. Library of Congress, Prints and Photographs Division.

of Bay City, Michigan, on literature; Miss Anna H. Jones of Kansas City, Missouri, on music; and Mrs. Dillie King Clark of Wilberforce, Ohio, with Mrs. Rosetta Lawson of Washington, DC, on the temperance movement. Reports were then presented by delegates of numerous church clubs.

Several resolutions were adopted to support issues vital to the social, economic, and political well-being of African Americans. One presented by Ida B. Wells-Barnett

advocating for anti-lynching legislation was supported as early as 1896 and saw a renewed vitality in the 1904 session. Issues related to discrimination by railroads and separate seating conditions on streetcars were discussed, and endorsements for the work of the Women's Christian Temperance Union and the expansion of more mothers' clubs were adopted. Despite the disappointment about their lack of participation in the festivities of the Fair, delegates diligently conducted their business. One of the most important acts of the session was to formally incorporate the NACW on July 14, 1904, and register it in the state of Missouri. Incorporation documents were signed by several members of the delegation, including Josephine Silone Yates, Hallie Q. Brown, Margaret Murray Washington, and Susan Vashon.[13]

But for the small group of women identified in the *St. Louis Palladium* (Susan Vashon, Mrs. B. K. Bruce, and a Mrs. Williams) appointed to draft a statement about the boycott, there would likely be little record of it outside of the minutes taken on the day the resolution passed. Fair president David R. Francis responded to the NACW in the *St. Louis Globe-Democrat,* stating that the World's Fair extended "a cordial invitation to all people, without regard to race" and further pledged the management to "do all within its power to prevent race discriminations."[14] The *Palladium* and the *Globe-Democrat* saw the value in printing statements from both sides of the issue.

Just as disturbing as the experiences of those who were exploited and disenfranchised at the 1904 World's Fair is the fact that most of these stories of discrimination and prejudice have gone untold when discussing the Fair's history and legacy. In an effort to tell the complete story of the Fair—the positive and the not so positive—this book is one step toward more fully honoring all those who have helped shape St. Louis history.

Linda M. Nance is the current national historian for the National Association of Colored Women's Clubs Inc., responsible for continuing efforts to preserve, protect, and promote the extraordinary narrative of this 128-year-old organization. She is also the founding president of the Annie Malone Historical Society. Through a series of lectures, tailored presentations, exhibits, displays, and classroom sessions she shares (with audiences 8 to 80) the life and legacy of the pioneering haircare and beauty icon Annie M. Turnbo Malone.

Dr. Arthelda Busch Williams is a retired elementary school principal in the Saint Louis Public Schools district. She is among four generations of her family who have been members of the National Association of Colored Women's Clubs Inc. She has served in several capacities, including Missouri state president, Missouri youth supervisor, and central region coordinator of young adults. Most recently, she served as the NACWC's national historian from 2018 to 2022 and is the organization's current membership chair. She earned her doctorate in adult and higher education from the University of Missouri–St. Louis, a result of her research on the NACWC.

Endnotes

1. Walter Johnson, "The Largest Human Zoo in World History," *Lapham's Quarterly Roundtable* (April 14, 2020).

2. Ibid.

3. E. L. Davis, *Lifting as They Climb* (Washington, DC: National Association of Colored Women, 1933), 44.

4. Charles H. Wesley, *The History of the National Association of Colored Women's Clubs* (Washington, DC: The National Association of Colored Women's Clubs, 1984).

5. Ibid., 60.

6. Black History in Two Minutes, "W. E. B. DuBois: The New Negro at the 1900 Paris Exposition," December 2020, https://www.youtube.com/watch?v=iLkjtXqQEI0.

7. Johnson, "The Largest Human Zoo."

8. Ibid.

9. Ibid.

10. Wesley, *Colored Women's Clubs*, 61.

11. "Give Out Official Statement Telling Why They Boycott the Exposition," *St. Louis Globe-Democrat*, July 14, 1904.

12. Wesley, *Colored Women's Clubs*, 62.

13. Missouri Secretary of State, *Article of Incorporation of NACW*, B-2868, 1904.

14. "President Francis Writes Colored Women that No Race Discriminations Are Intended," *St. Louis Globe-Democrat*, July 15, 1904.

References

Black History in Two Minutes. "W. E. B. DuBois: The New Negro at the 1900 Paris Exposition" (December 2020). https://www.youtube.com/watch?v=iLkjtXqQEI0.

Davis, E. L. *Lifting as They Climb.* Washington, DC: National Association of Colored Women, 1933.

Eisen, Erica. "Specimen Days: Human Zoos, the 1904 World's Fair, and the Gender of Imperialism." *Lady Science* no. 53 (February 2019).

"Give Out Official Statement Telling Why They Boycott the Exposition." *St. Louis Globe-Democrat,* July 14, 1904.

History of the Club Movement Among the Colored Women of the United States of America, as Contained in the Minutes of the Conventions, Held in Boston, July 30, 1895, and of the National Federation of Afro-American Women, Held in Washington, DC, July 21, 1896. Washington, DC: National Association of Colored Women's Clubs, 1902.

Johnson, Walter. "The Largest Human Zoo in World History." *Lapham's Quarterly Roundtable* (April 14, 2020).

Jones, Martha S. *Vanguard: How Black Women Broke Barriers, Won the Vote, and Insisted on Equality for All.* New York: Basic Books, 2020, 149–174.

Mathiesen, Alex. "The 1904 World's Fair in St. Louis" (May 2020). https://www.youtube.com/watch?v=XGjeNUAWZTA.

Missouri Secretary of State. *Article of Incorporation of NACW,* B-2868. 1904.

"Mrs. Booker T. Washington Claims Colored Women Are Discriminated Against." *St. Louis Globe-Democrat,* July 13, 1904.

National Association of Colored Women's Clubs. *Articles of Agreement.* Missouri Secretary of State, B-2868. July 14, 1904.

"President Francis Writes Colored Women that No Race Discriminations Are Intended." *St. Louis Globe-Democrat,* July 15, 1904.

Wesley, Charles H. *The History of the National Association of Colored Women's Clubs: A Legacy of Service.* Washington, DC: The National Association of Colored Women's Clubs, 1984, 60–64.

SPECTACULAR TECHNOLOGY AT THE ST. LOUIS WORLD'S FAIR

By Dave Walsh

St. Louis . . . is central as to the nation . . . and here are gathered the triumphs of the ages, the glories of art, the higher expression of the marvels of machinery with which are wrought revolutions, not destruction, but of construction—works of beneficence, the peace that wins the victories of mankind, that replenish the earth, and sustain the people in their liberty and prosperity.

—Murat Halstead [1]

The writer of the above epigraph, Murat Halstead, was a prominent 19th-century journalist and editor who, in 1904, wrote a fun if sensational guide to the Louisiana Purchase Exposition. The nearly 500-page tome demonstrated Halstead's abiding love for all the Fair hoped to stand for, as well as his affection for the exposition's leaders, its built environment, and its overwrought decorative architecture. His book includes a map of the world titled *St. Louis as the Center of Civilization*. As though that exaggeration weren't enough, his image places the city almost exactly between the nations of the far Pacific on the left and the nations of Western Europe on the right.[2] To Halstead, St. Louis

View of the DeForest Wireless Telegraph Tower from the Department of Electricity. Photograph by Official Photographic Company, 1904. N20589.

was the best possible location for a World's Fair showcasing an emerging 20th century so singularly important in Western history it was to be as great as "any thousand years that have gone before." He retains this penchant for overstatement throughout his account, in keeping with the Fair's principal interest to craft a very grand story of Western magnificence. The exposition's president and principal evangelist, David R. Francis, designed a visitor experience framed by exaggerated scale and visual stimulation. In a brief introduction to the Fair's official guidebook, the editorial team claims that the event's "very magnitude and infinite variety" would provide fairgoers with access to "whole civilizations, entire epochs [and] the complete developments of peoples." Such bold overstatement is commonly found among artifacts produced by the Fair's managing company, by vendors and tourism companies, and, perhaps most important, by visitor testimonials.

For organizers, a successful Fair meant far more than turning a profit. They wanted to create an experience so profound and overwhelming that visitors would be changed by an "educational and moral" training as citizens of the newly modern world—an ambition that permeated every detail of the Fair.[3] Visitors expected encounters with materials, people, and cultures foreign to their everyday. They expected to learn within the ornamental trappings of exoticism and leisure. They expected fun. They sought explanations that connected civilizational history to Western modernity while also gazing into the future. If marketing materials trained visitors in these expectations, the visual experience delivered on them. At street level there was something to see in all directions—huge buildings, ornate statuary, vibrant gardens and landscaping, wide streets, water features, and, of course, the attactions of the Pike—all competing for attention. Rendered small by buildings and ornamentations many times out of scale with human perspective, visitors could understandably claim to be *impressed* in two senses of the word: first, as a condition of being amazed, and second, as an experience of being imprinted upon by a messaging logic integrated into every sensory experience.

This essay's title, "Spectacular Technology," describes how technological material culture fit into this same program. Enormous mechanical things leveraged the technique of dominance-by-scale as evidence for unassailable arguments of the West's globe-spanning superiorities in applied science. These objects embodied the spirit of industrial ingenuity as found chiefly in American enterprise and labor. While visitors understood that the palatial buildings jeweled with ornate decoration would dematerialize after the Fair, they were no less awestruck by the built environment's seeming permanence; it's possible that part of the Fair's allure drew upon the knowledge that most of the buildings were indeed temporary. But the technologic exhibits promised exactly the opposite: a material permanence that evoked visions of a modern nation that tamed nature; that promised limitless ingenuity and inventiveness; and that offered broad, unmappable horizons of future wealth.

The term *spectacular* references an arrested attention, one locked into singular focus by visual stimulation. David Francis and his executive leadership sought to use this stimulation to elevate moral, rational, and patriotic arguments of American identity within the broad traditions of Western cultural and material

This solar furnace, known as a Pyrheliophor, was designed and built by a Portuguese priest nicknamed Father Himalaya. Essentially a giant science experiment, it was made up of 6,117 mirrors and could generate temperatures up to 7,000°F. Unknown photographer, 1904. N15854.

sophistication. Just as the history of Western achievement was anchored in the technological objects of the Fair's various palaces, the future was anchored in the theater and awe of oversized machines, as embodied in M. A. Gomes's solar furnace, the Pyrheliophor, which could generate temperatures up to 7,000°F, and in Lee DeForest's 300-foot-tall wireless communications tower. Fair organizers understood that well-crafted public spectacle was the most effective way to train visitors in the values of emergent national and regional greatness. In 1904, nothing quite convinced an audience to take pride in their nation's industriousness more than displaying machines of massive proportions.[4]

If excess was a fundamental ambition, then the Fair's opening day required block-buster entertainment. April 30, 1904, saw not just one but *two* opening ceremonies, set to happen concurrently in different time zones. Halstead offers a rich account of how President Roosevelt in Washington, DC, and David Francis in St. Louis planned to host festivities that were somewhat typical in scale and activity in their respective cities. But making them both larger and grander meant launching the ceremonies simultaneously, and the key to doing that was the wonder of wired communication. Timing is everything in Halstead's account, and his plot hinged on whether the telegraph signals would be sent and received precisely as planned. South of the White House, artillery guns were set to explode ceremonial munitions, and in St. Louis the Cascades were ready to surge with water. Equipment in the

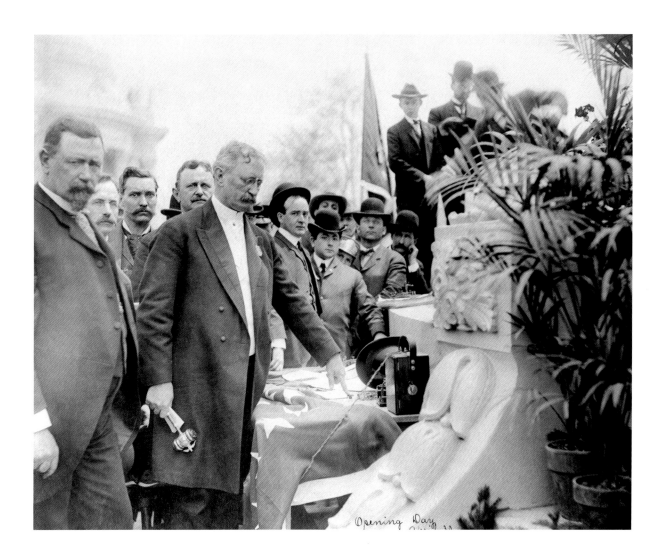

Opening Day

Palace of Machinery was poised to start a great rumble of production. Visitors waited to sing "The Star-Spangled Banner." All that activity depended upon electrical signals sent to the nation's capital and back. As Halstead paints the moment, the rising tension comes from unspoken questions about whether the technical infrastructure would work. If it did, then the audacity of complexity would become the appropriate symbol of all the Fair's logic. If not—well, no alternative is offered. It all rested on the "magic in the touch of the golden key."[5]

Everything went as planned. Both Roosevelt and Francis turned their ceremonial keys in their ceremonial telegraph boxes to release the pent-up fever of the crowds gathered in both cities. The boxes, of course, were showpieces that drew attention away from the complex logistics and tech hidden just out of sight. While Halstead clearly enjoyed the ceremonial pomp and artificial tapestry of the boxes and the festivities, he prized the Louisiana Purchase Exposition because—unlike previous Fairs and unlike the 1904 opening ceremonies—visitors would see behind

the steely curtain of finished machines to witness the elaborate, complex inner workings of these objects. In so doing, he argued, visitors would witness complexly organized infrastructure as the undeniable fruits of a democratic society that rightly embraced capital pursuits and technological innovation. They would be convinced that a more peaceful, orderly world was imminent, one largely free from labor and tyranny.

These were ambitious goals indeed. Halstead had his preferences and loquacious embellishments, but in exalting the city and nation, he echoed the sentiments of Fair organizers. This meant removing social and political nuance from nearly every utterance and turning every occasion of racial display into arguments in favor of natural order. Halstead's contribution to this is seen in his flattened map of the world that placed St. Louis at the center of civilized territory. He, along with Fair organizers, saw no problem putting the conquered next to the works of the occupier because such contrasts were essential for understanding how nature selects only some societies to advance. The rest would become wards of successful and beneficent societies, expectantly hopeful (and grateful) to ascend into categories of acceptance. In this logic the past proves the present, the present anticipates a grand future, and technological and economic power wrought by modern civilizations rightfully dominate the globe. The great works of locomotive history in the Palace of Transportation, for example, demonstrated that Western modernity won the present and would go on to win the world.[6] Just as the muscularity of American

Locomotive testing on display in the Palace of Transportation. Photograph by Official Photographic Company, 1904. P0166-00125.

technological industry forged the grandness of the Fair's moment, the folderol of the opening ceremonies showed that continued technological innovation in telecommunications and, of course, free enterprise, would bring about a future vision of civic and urban orderliness.

<center>◆▶◀◇▶◀◆</center>

Wired communications had become naturalized within the social order for decades, and telephony was now a household technology—literally.[7] That the telegraph performed as expected during the Fair's opening ceremony signaled that the age of experimentation in modern communications was over. The next phase required cutting the telegraphic cord and investing in wireless, and inventors and corporations fought bitterly to get there first.

Making a spectacle of wireless technology was tricky. Doing so required proxy artifacts because the thing itself, the communication, had no visible physical properties. It was up to machines, wires, and large communication structures to attract visitors' attention and prove that the technology worked. Much like the drama of the dual opening ceremonies in St. Louis and Washington, DC, the proof was in the sending and receiving of visitor messages.[8] These experiences were found throughout the fairgrounds but principally housed in the DeForest Wireless Telegraph Tower.[9] At 300 feet tall, the tower was a long-range visual marker for those navigating the palaces and Pike by day and night. As Edmund Mitchell wrote for the *Los Angeles Times* in July 1904, so much voltage was dedicated to distance transmission—upward of 20,000 volts—that fairgoers would "hear a hundred yards away" the sound of those volts charging through the transmitter lines. The experience was so loud and rhythmic that, according to Mitchell, a "trained telegraphist" could understand the sounds of "dots and dashes quite easily." There was a standard telegraphy machine in the operator's booth on the tower's observation deck, staffed by a dispatcher who sent messages throughout the day. From outside the booth visitors could take in the sight of the fairgrounds or stand inside and watch the operator work. Whether inside or out, they would hear the electric current "screech" with every tap of the telegraph key. The experience, Mitchell noted, was deafening, "and the man at the instrument [had] his ears filled with cotton wool."[10]

A similar sight-and-sound sensory experience was found at DeForest's exhibit within the Palace of Electricity. The exhibit's perimeter was marked by three 70-foot wooden towers that nearly reached the rafters.[11] From each wooden tower descended high-voltage wire antennas that connected to the signal station desk at ground level, where operators sent and received messages. The "sharp and penetrating crackle" of currents zapping up the lines could be heard throughout the building. While this was appetizing entertainment, the highlight of the visitor experience was writing out a message at a sending station across the building and then retrieving a printed copy at the operator's station moments later.[12] Visitors could also retrieve these messages at stations throughout the eastern fairgrounds, including at least a few "wireless automobiles" dotted around the palace concourse. These four-wheeled

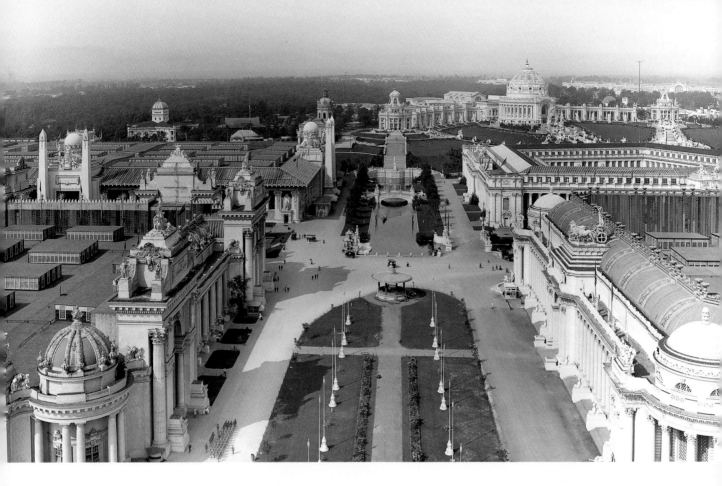

autos—roughly the size of a small horse cart—were battery powered and lacked doors, an engine compartment, or a steering wheel. Instead, a rudder-like handle turned the front wheels. Most of the area behind the cramped driver's seat was reserved for the batteries. Atop the batteries sat a square about 4 feet high with glass panels on all sides that allowed visitors to watch as messages came in.

Every contact experience for visitors made visible the underlying infrastructure of wireless technology. DeForest's central tower's steel framing was left unadorned, as were the three wooden transmitting towers in the Palace of Electricity so visitors could see the girders, support beams, and wires. DeForest also built a long-range antenna station on Art Hill. The transmitting equipment was housed in a small, plain wooden structure that—unlike most of the Fair's other buildings—lacked any aesthetic appeal. The visual allure was saved for the massive pole behind it that held runs of thick wire. The wooden mast stood over 200 feet tall and was capped with a 40-foot-long wooden cross brace. The wires, each about 250 feet in length, descended from the mast into a broad canopy encircling the station house. The structure's nakedness promoted its practicality as a thing of pure engineering ingenuity, the perfect proxy for grasping the fundamentals of invisible applied science. A short article in the June 12, 1904, edition of the *St. Louis Post-Dispatch* proclaimed that crowds stood in "wonder at the distance annihilating device," a

View from the DeForest Wireless Telegraph Tower over the Plaza of Orleans toward Festival Hall and the Cascades. The Palace of Liberal Arts is in the left foreground and the Palace of Manufactures is in the right foreground. The wooden mast of the DeForest long-distance transmission station is visible at the top right of the image. Photograph by Official Photographic Company, 1904. N16095.

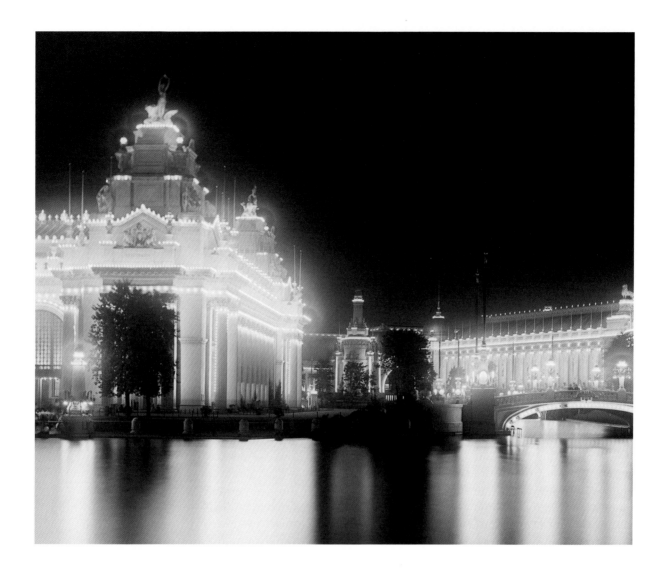

Night view of the Palace of Electricity at left and the Palace of Varied Industries at right. The Grand Basin is in the foreground. Photograph by Official Photographic Company, 1904. P0166-523-4g.

wonder so enrapturing it diminished the allure of the experimental airships taking flight along Washington University's northern edge, above what is now Forest Park Parkway.[13]

Fairgoers delighted in sending and receiving messages, and the same infrastructure was used as proof of concept to attract the attention of business leaders. The central observation tower sent messages to the downtown newspaper headquarters of both the *Post-Dispatch* and the *St. Louis Star*, each equipped with rooftop receiving antennas. Inside the pressrooms, telegraph stations decoded dispatches from their reporters at the Fair. As noted in the *Electrical Review*, the dispatches were sent "quickly and surely as by wire," and about "5,000 words a day" were broadcast to the respective headquarters.[14]

Newspapers publicized the milestones that DeForest had achieved in expanding the practical limits of wireless distance communications. In August

the *Post-Dispatch* reported that messages sent from the Fair reached a tower in Smithton, Illinois, about 20 miles east. The next month the same newspaper lauded the successful installation of a DeForest tower in Springfield, Illinois.[15] Yet these accomplishments were almost quaint compared to the major achievement that came about a week later, on September 10, when the fairgrounds successfully sent and received messages with a relay station in Chicago, some 300 miles away. This new distance record grabbed headlines in newspapers and trade publications, including *Telephone Magazine*, *Railway Age*, and Britain's *Manchester Guardian*, and it helped DeForest earn the Fair's grand prize for General Excellence in Wireless Telegraphy. These breakthroughs proved that wireless communication was the business technology of the future.

<center>⇒▷◁⇐</center>

Wired communications already wrapped continents and ocean floors in cabling, and expanding the networks was expensive. By contrast, wireless promised freedom from the earthbound materiality of the legacy tech, using the open air to send information and, in daring optimism, even electrical power. After wireless telegraphy was so sensationally featured at the St. Louis World's Fair, futuristic renderings of the new 20th century showed wirelessly controlled automobiles sensibly distributed along high-speed infrastructure. Even with many more vehicles, traffic congestion was not a problem. Cities of the future would be orderly, clean, and capable of housing ever-increasing populations. They'd have conveniences that would relegate tried-and-true technologies to antique status. The future would outgrow inconveniences and limitations that were the hallmarks of parochial ways of thinking about society and space. Instead, the new incarnation of the industrial society would sprawl everywhere to dominate land and sea, and even high into the air.

An illustrator for the *Greater St. Louis Christmas Magazine* captured this imagination in a 1910 drawing titled *A Forecast: Looking Up Olive Street, St. Louis, Missouri, A. D. 2010*. The illustration is not noteworthy for its technical merits but rather for how it captures the vision of an idealized St. Louis that the Fair relentlessly promoted. This future St. Louis operates in the wake of the Fair's grandeur and has all the trappings of success: a booming population, a ridiculously tall and dense downtown, oversize ornamental civic structures on the waterfront, an abundance of efficient transportation. Airships servicing the upper stories of the towers on the left signal that mass transportation had moved beyond the horizontal to conquer the vertical. All of the problems that had beset metropolises of the 20th century were now solved, from waste removal to overcrowding to poor roads. In this world individual transport no longer exists—not horses, not automobiles, and certainly not bicycles. The machines on the street are a version of mass transit, and pedestrians and vehicles move in harmony (in no small part because bicycles are clearly not allowed—a slight that echoes long-held animosity against the machines in the city). The world had evolved into a coherent, rational social order, and the evidence of its thriving is everywhere.

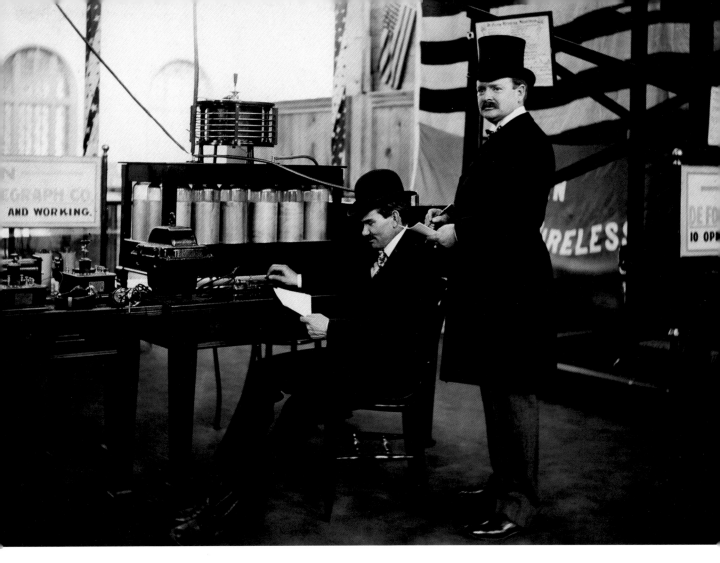

The essential technology for this new future? Wireless. There are no telephone poles, no telephone wires, no electrical lines strung between buildings. The infrastructure is not merely buried, it has become obsolete. The half-dozen street cars—which recall the models the St. Louis Car Company displayed and sold at the Fair—operate not with electrical wires and track but on wirelessly broadcast electricity. The same technology also regulates information. There are no traffic lights or stop signs because the transport machines receive centralized data that organize their movement and schedule. The collective of airships reflects a similar kind of traffic management. Such mechanical and social orderliness requires some form of central operation and transmission that's broadcast from a single source. Here, just like at the Fair, a tower serves as tangible proof that wireless works.

The tower in the background of the illustration is so hilariously huge that, by scale, its base must stretch at least from midtown to Clayton and University City. It clashes with the architectural aesthetic, and its purpose is a bit vague. (Perhaps a multistory airport?) It is garish, steely, and without material surface. Although its curves and arches operate within a visual futurism that's typical of the genre, its

A FORECAST

LOOKING UP OLIVE STREET, ST. LOUIS, MISSOURI, A. D. 2010.

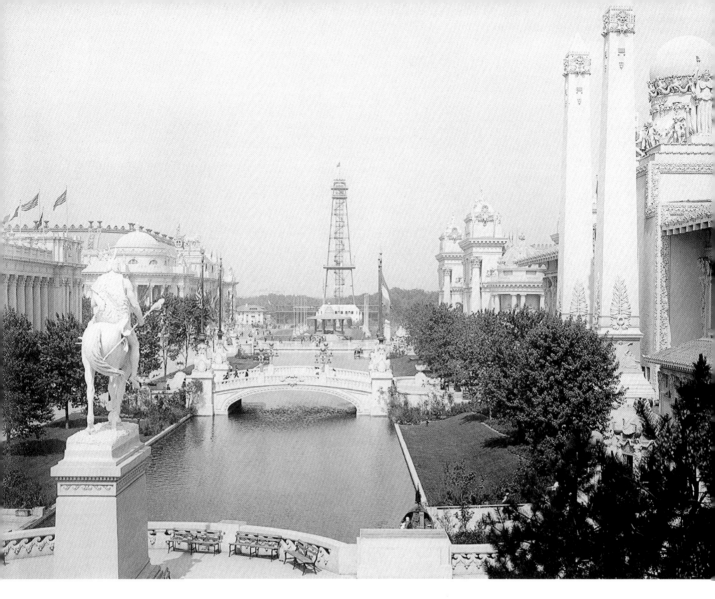

This photograph's composition—placing the DeForest Wireless Telegraph Tower at its center—shows an idealized city, free of disorder, and bears a strong resemblance to the illustration *A Forecast*. Courtesy of St. Louis Public Library.

inclusion in the illustration seems entirely unnecessary. So why is it there? A visitor photograph from the Fair may provide an answer.

The photo above is one of many that use the DeForest Wireless Telegraph Tower as a visual reference point, and it mirrors almost exactly how the illustration uses a tower as a visual focus. The photograph depicts a static model of a city perfected in its moment, one organized for social and material cooperation. There is no hint of disorder or decline, no garbage, no pollution, no crime. Most important, there are no wires.

The DeForest tower hulks in all its uncompromising, futuristic design. Even at a distance it is far taller than the palaces in the foreground. It is visually out of place compared to the Fair's Beaux Arts buildings, an ugly contrast to the smooth walls and ornate motifs. Set in the background, the tower signals the future, the inevitable outcome of all that's symbolized in the foreground. The same details are at work in the illustration. The buildings in the foreground bear the same

architectural language and frame the same present-to-future movement of history, evidence of the Fair's influence on local imagination even years after it ended.

In both images, the towers are the sources of energy and communication. Their incoherence with the built environment is the engineering aesthetic of the future, one that values a style of efficiency over performance of beauty. Both worlds cast aside mention of social disorder in favor of a coherent new machine age that runs as much on power as it does on information. In both, the clutter of communication and power generation—from telephone, telegraph, and electrical poles to wires to substations and transformers—are invisible because the new era of tech dominance is now centered, literally and figuratively, in the towers alone.

American automobiles on display in the Palace of Transportation. Photograph by Official Photographic Company, 1904. N33841.

The 1904 World's Fair is now, of course, no longer in living memory of any St. Louisan, but there is no shortage of images, souvenirs, books, websites, and videos that remind us what it was and what it was like to have been there. That such an industry of remembrance exists is proof that Francis's ambition that the Fair's "influence on the future" be "deep and lasting" succeeded. Francis argued that the Fair would "have a place in history more conspicuous than its projectors ever conceived," and he was right.[16]

The Fair's "conspicuous" place in history was the fixed point in time when all the material, philosophical, scientific, and engineering prowess of the West stood in stark contrast to the societies deemed "primitive" and "savage," purposefully displayed in the fairgrounds' farthest reaches. The future of the West emerges from this singular moment, so Francis claims (and Halstead would agree), because here power in its more animate and tangible forms was broadcast for admirers and enemies alike. Technology and technological infrastructure won the world for the West, and it would continue to drive civilizational change toward ever greater improvements in efficiency and convenience. The Filipinos and the Indigenous peoples of North and South America who practiced different economies and value systems were cast as natural contrasts to the assumed superiority of Western culture and industry.

The Fair's human zoos reminded fairgoers that there would be no return to a simpler, less technologically advanced time because those cultures would soon be overwritten by the inevitable future engineered for comfort, leisure, and convenience—at least the fairgoers' own. The technology exhibits all conveyed the same idea, that subduing nature was the only way forward into a century abundant with opportunity. The many downsides were overlooked or omitted altogether in favor of believing that tech is the answer to every problem—a similar story we tell ourselves today. This narrative operated in culture long before the Fair, but in that space it was expertly broadcast to visitors and the reading public alike. And from their testimonials, their memoirs, souvenirs, and all the ephemera of the memory market that circulates today, that narrative has become our own.

Dave Walsh is a lecturer in the American Culture Studies program at Washington University in St. Louis, specializing in the history and cultures of technology in the United States. He is also faculty lead for the STL in AMCS program initiative and faculty lead of the Harvey Scholar mentorship program. His principal research focuses on the history of computational machines after World War I, but his classes cover tech and culture topics from the 19th century to now. He also researches, speaks on, and teaches courses on the technical and cultural history of the internet, hacking and hacker culture, surveillance, and propaganda. This essay emerges from a course on the World's Fair focused on memory and narrative, and he thanks all of the students who've participated in the investigation of what the Fair was and what it has become in the public imagination—graduation points to you all. He's always keen for a conversation! Reach him at dgwalsh@wustl.edu.

Endnotes

1. Murat Halstead, *Pictorial History of the Louisiana Purchase and World's Fair at St. Louis* (Philadelphia: Bradley, Garretson and Co., 1904), 185.

2. Ibid., 171.

3. M. J. Lowenstein, *Official Guide to the Louisiana Purchase Exposition at the City of St. Louis, State of Missouri, April 30th to December 1st, 1904* (St. Louis: Louisiana Purchase Exposition Co., 1904), 7.

4. The Palace of Transportation, among the largest buildings, was packed with the heavy machinery of the modern transportation age. Its chief exhibit, the *Spirit of the Century,* was an elevated locomotive engine that spun around on an exposed railway turntable. It did nothing useful or practical but rather operated as a massive advertisement. M. A. Gomes's Pyrheliophor—a solar furnace—was likewise not a useful or deployable technology; it was instead a giant science experiment to harness solar radiation for industrial use. Like *Spirit* and the DeForest Wireless Telegraph Tower, the Pyrheliophor was a popular attraction because no one understood what it did or what it was for. Even so, its massiveness assured fairgoers that the future would be won by innovation and commercial industry.

5. Halstead, *Pictorial History,* 187.

6. The exhibit put artifact machines, or their models, in a chronological order to tell a specific history of technology and industry. Writing in the October 1, 1904, edition of *Scientific American,* Herbert T. Walker focused on how each machine was the first at something: the first experiment harnessing steam power for locomotion, the first engine to run in Chicago, the first with a particular innovation, or the first engine in New York to pull passenger cars (which leaned heavily on style and design features from horse-drawn carriages). Walker ends with a quick catalog of the modern machines, ones whose weight and hauling power dwarf any predecessors. His report follows a narrative framework that organizes machines into a coherent story of engineering prowess and how iterative changes over time yield fruits of a prosperous industry and, importantly, a nation.

7. It is important to note that the telegraph and the telephone were technologies fully integrated into urban life, at least in the more populous metros. The present state of communication tech was likewise fully integrated into the Fair. Visitors could make landline phone calls to other buildings and exhibits on the grounds and call people and businesses in St. Louis. They could even make domestic long-distance calls. The infrastructure to support this wired connectivity was provided most prominently by American Telephone and Telegraph Company, though local connectivity to the fairgrounds and the St. Louis community was also serviced by the Kinloch Telephone Company. Massive switchboards were installed with capacity for over 10,000 lines. See Cloyd Marshall, "Notable Electrical Exhibits at the St. Louis Exposition," *Electrical Review* 44 (July 1904).

— *Continued* —

Endnotes

8. The September 3, 1904, edition of *Electrical Review* features a story about the DeForest exhibits and lauds the hands-on approach to visitor education: "To the public there is a great deal of mystery about communication without wires or other connection. By actually hearing the messages sent and received, the uncanny impression disappears and the commercial possibilities become more apparent to all."

9. Fun fact: The DeForest Wireless Telegraph Tower was one of the Fair's most famous exhibits, but it was recycled from its original installation in Niagara Falls and sent to St. Louis for reassembly during the final weeks before the Fair opened. See: W. E. Goldsborough, "Electricity at the St. Louis Exposition," *Electrical Age* 32 (April 1, 1904).

10. Edmund Mitchell, "Many Marvels of Electricity," *Los Angeles Times*, July 17, 1904.

11. These were smaller versions of installations that would soon be operating at Cape Flattery, Washington, to service Alaska and the Pacific islands.

12. "Wireless Telegraphy at the St. Louis Exposition," *Electrical Age* 33 (September 1, 1904).

13. "Crowds Stand About in Wonder at the Distance Annihilating Device," *St. Louis Post-Dispatch*, June 12, 1904.

14. "Overland Wireless Telegraphy at St. Louis," *Electrical Review* 45, no. 10 (September 3, 1904). Beyond proving the value and reliability of the service to local enterprises, it is unclear if the DeForest Wireless Telegraph Tower charged fees for sending transmissions to the newspapers or, more generally, what the parameters were for its business arrangements. The partnership was at least clever for DeForest as it built company promotion into almost every message it sent to the *Post-Dispatch*. The newspaper printed an advertisement beneath the headline and above the copy that stated the dispatch was received "Via American DeForest Wireless Telegraphy."

15. "Wireless Messages Flash over Illinois," *St. Louis Post-Dispatch*, September 6, 1904.

16. Quoted in Halstead, *Pictorial History*, 203.

References

"Crowds Stand About in Wonder at the Distance Annihilating Device." *St. Louis Post-Dispatch*, June 12, 1904.

Goldsborough, W. E. "Electricity at the St. Louis Exposition." *Electrical Age* 32 (April 1, 1904).

Halstead, Murat. *Pictorial History of the Louisiana Purchase and World's Fair at St. Louis.* Philadelphia: Bradley, Garretson and Co., 1904.

Lowenstein, M. J. *Official Guide to the Louisiana Purchase Exposition at the City of St. Louis, State of Missouri, April 30th to December 1st, 1904.* St. Louis: Louisiana Purchase Exposition Co., 1904.

Marshall, Cloyd. "Notable Electrical Exhibits at the St. Louis Exposition." *Electrical Review* 44 (July 1904).

Mitchell, Edmund. "Many Marvels of Electricity." *Los Angeles Times*, July 17, 1904.

"Overland Wireless Telegraphy at St. Louis." *Electrical Review* 45, no. 10 (September 3, 1904): 330–331.

"Wireless Messages Flash over Illinois." *St. Louis Post-Dispatch*, September 6, 1904.

"Wireless Telegraphy at the St. Louis Exposition." *Electrical Age* 33 (September 1, 1904): 161–167.

WORLD'S FAIR PHOTOS, ART, AND ARTIFACTS
IN THE MISSOURI HISTORICAL SOCIETY COLLECTIONS

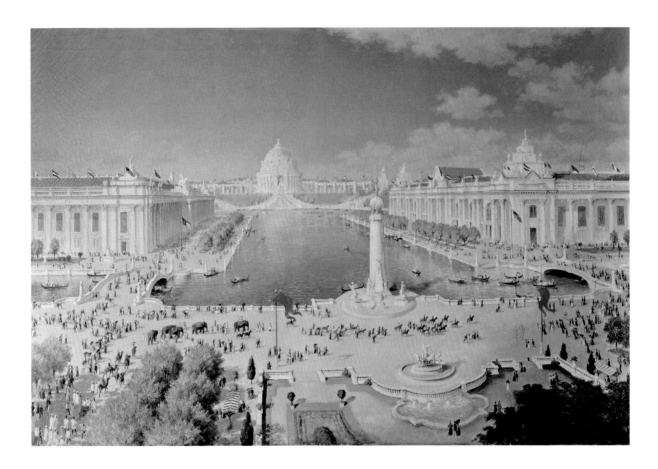

View Looking South towards Festival Hall, 1904

John Ross Key was not only a renowned landscape artist in the post–Civil War era but also the grandson of Francis Scott Key, author of the text of "The Star-Spangled Banner." Before coming to St. Louis in 1904, John Ross Key had painted vistas from several other World's Fairs, including Chicago in 1893, Omaha in 1898, and Buffalo in 1901. This portrait is in his signature style: sweeping, aerial views that contrast fairgoers with the buildings' grandeur. This painting shows the first view of the fairgrounds most visitors would see when they entered. The obelisk in the center, just inside the main entrance on the edge of the Grand Basin, is the Louisiana Purchase Monument.

Oil on canvas by John Ross Key
Gift of Louisiana Purchase Historical Association
1926-053-0001

Canisters of preserved pears and tomatoes, 1904

The original donor of these items is Arlan Gaus, whose father, Arthur, was a professor emeritus in the University of Missouri's agriculture department from 1930 until the early 1970s. The jars had been in his father's office for years, and after he retired and no longer had an on-campus office, they went into the Gaus household. The younger Gaus took them to the State Historical Society of Missouri. After looking at images of displays in the Palace of Horticulture, researchers determined that these two canisters were at the 1904 World's Fair. A label on the jar identifies the pears' variety as "Flemish Beauty," but the tomatoes are unmarked. It's unknown which state brought these fruits, but it is possible they were part of the Missouri display.

Gift of the State Historical Society of Missouri
2014-131-0001, 2014-131-0002

Pencil drawing of Otto Schwerdtmann, 1904

Sidewalk artists were at the ready to capture fairgoers' likenesses. This one is of 41-year-old Otto Schwerdtmann. He was born October 9, 1863, in Baltimore, Maryland, and then moved to St. Louis with his family in 1880. He married Amalie Heinicke of Collinsville, Illinois, in September 1889 and went on to inherit his father's business, Schwerdtmann Toy Company. The couple lived at 3532 Flora Court in the Compton Heights neighborhood and had five children. Schwerdtmann died in August 1947; he and Amalie are buried in Concordia Cemetery.

Gift of Robert C. Schwerdtmann
1980-080-0001

Marble sculpture of *Aurora*, 1904

Aurora was the goddess of dawn in ancient Roman mythology. Here she's depicted by the Italian sculptor F. Saul in a graceful pose wearing fine adornments. This statue wasn't exhibited in the Palace of Fine Arts, however. *Aurora* was part of the Italian display in the Palace of Manufactures. Artists from Florence were commissioned by Italian marble firms to make sculptures to sell to Fair visitors.

Statue by F. Saul
Gift of Mrs. Velma Neiman
1979-035-0001

Vase purportedly displayed in the Japanese exhibit at the World's Fair, 1904

Harry Darby Silsby came to the United States from Brighton, England, with his mother and father in the 1860s. At some point he and his brother Jim opened a hardware store in Osceola, Missouri, to sell supplies to people headed west to find gold. But he felt that he could make more money if he made the picks and axes himself, so he moved to Springfield and opened a foundry. Even though his business was successful, he sold it to the Frisco Railway, which tore down his buildings so its railroad could run through Springfield. Silsby then opened an import business selling pottery and other goods. He purchased this vase at the World's Fair for $500. It was handed down through the generations of the Silsby family.

Gift of Joe Silsby
2018-094-0001

Trophy awarded to Samuel S. Jones, 1904

St. Louis was the first US city to host the Olympic Games. Held over six days during the Fair, it was the first Olympics to award gold, silver, and bronze medals. Winners of track and field events also received cups like this one. Samuel S. Jones, who represented the New York Athletic Club, cleared 1.8 meters—nearly 6 feet—to place first in the high jump on August 29, 1904. John A. Holmes donated this cup for the event.

Gift of James S. and Connie Stephens
2004-022-0001

Honorary referee badge, 1904

Officials had planned for athletic-style events to continue throughout the Fair's run, but they dedicated one week, August 29 to September 3, to official Olympic events. Various dignitaries were named honorary referees. This ribbon may have been worn by Frederick J. V. Skiff, the Fair's director of exhibits.

X04813

Silver spoons featuring World's Fair buildings, 1903

These spoons picturing World's Fair buildings in relief were collected by Charles Wasserman. Near the bowl of the spoons, the handles are decorated with the years "1803" and "1903"—the latter a reference to the Fair's original date, meant to celebrate the centennial of the Louisiana Purchase before delays pushed it back to 1904. Images of Native Americans, covered wagons, and trains at the top of the handle evoke the westward expansion of the United States that the Louisiana Purchase made possible.

Pictured from left to right, top to bottom: the Palace of Mines and Metallurgy, the Palace of Agriculture, the Missouri Building, the Palace of Manufactures, the Palace of Machinery, the Palace of Fine Arts, the Palace of Liberal Arts, the Temple of Fraternity, the Palace of Varied Industries, the Palace of Education and Social Economy, the Palace of Transportation, the Cabildo, the Administration Building, and the US Government Building.

Gift of Rita Wasserman
2009-024-0003

Light bulb used on the Ferris wheel, 1904

Although we don't think much about artificial light today, illumination was quite a spectacle at the 1904 World's Fair. Electricity wasn't new in 1904, but most people had never seen it used on such a large scale. Fair organizers wanted to show fairgoers both the product and the process: The Palace of Electricity had a working assembly line that demonstrated how incandescent light bulbs were made.

Gift of M. B. Manovill
1977-081-0000

Ruby glass personalized "Thelma," 1904

Nellie and her sister Marian were two of eight siblings. Their mother was only in her 30s when she died; Nellie was an infant. Their father could not care for all eight children, so six of them were placed in the orphanage that would later become known as the Annie Malone Children & Family Services Center. But because the orphanage did not accept children under age one, Jesse and Lula Williams took the sisters into their Olive Street home in 1934. They were both teachers and had a daughter named Thelma. The sisters stayed with the Williamses until the mid-1940s, when Marian was about 10. By then their father had remarried and could again care for all eight children in their home near the border of Berkeley and Kinloch. Although ruby glass was one of the most common Fair souvenirs, this one owned by the Williams family is especially significant because not many African Americans attended the Fair.

Gift of Marian B. Bradley and Nellie M. Burns
2010-084-0002

A River Runs Through It, 2023

This mixed-media piece by Ria Unson conveys the artist's connection to the 1904 World's Fair and how she continues to wrestle with the impact that colonialism has had on her and her family. Ramon Ochoa, Unson's great-grandfather, was brought to St. Louis by Fair organizers as part of the Pensionado program. He was not exhibited as a member of the Philippine Reservation but rather served as a waiter and exhibit guide, in part because he spoke fluent English. Even so, the reason for Ochoa's presence at the Fair was the same as the other Filipinos: to justify America's colonization of the Philippines by showing that some Filipinos were more "civilized" than others, thanks to the influence of US imperial rule.

———————————————

Mixed media of wood, canvas, hemp, paper, and soil by Ria Unson
Gift of Ria Unson
2023-141-0001

Jefferson Guard uniform worn by Norton H. Pearl, 1904

After growing up in Eastport, Michigan, Norton H. Pearl moved to St. Louis in 1904 to find a job at the World's Fair. He first worked as a waiter at the Administration Restaurant and then was hired into the Jefferson Guard, the Fair's security force. He was sworn in as Guard #13 in Company E and worked night duty at the Palace of Fine Arts.

Made by Fechheimer Brothers Co., Cincinnati, Ohio
Gift of Dorothy Waite Pearl
1979-019-0002

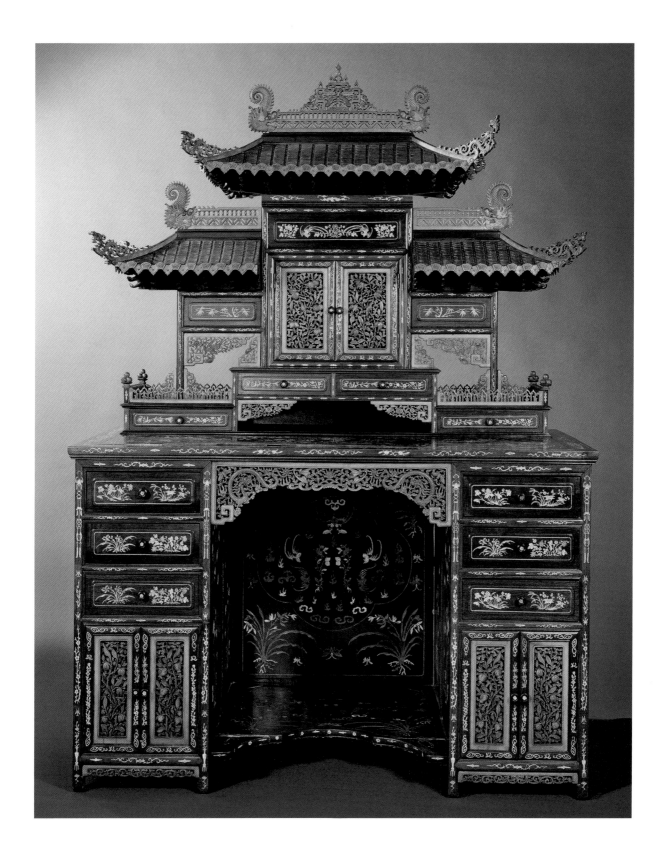

Chinese rosewood and ivory inlaid desk, ca. 1899

Unlike traditional Chinese furniture design, this kneehole desk from northern China's Ningbo region was intentionally made with numerous drawers so that it would appeal to Western tastes. The intricate inlaid designs depict typical Chinese vignettes and symbols. The desk and accompanying chair were purchased from China's display in the Palace of Manufactures and shipped to San Francisco. Frank C. Dougherty purchased the desk in 1937, and his son, Howard, donated it to the Missouri Historical Society in 1977.

Gift of Howard William Dougherty
1977-114-0000

Women's embroidered Chinese foot-binding shoes, ca. 1900

The Louisiana Purchase Exposition marked the first time China participated in a World's Fair. The country had a presence in the Palace of Manufactures and a national pavilion, but even so, the Chinese Exclusion Act—which banned Chinese immigration—limited its involvement. These foot-binding shoes are said to have been on display at the Fair. In Chinese culture a woman's foot was considered perfect if was 4.3 inches long and shaped like a lotus. To obtain that shape, women's feet were broken and then bound. The custom was outlawed in 1911.

Gift of Mrs. Delbert Wenslick
1991-039-0001

View of the central nave of the Palace of Agriculture, 1904

The foreground of this photograph shows a stand with a sign reading, "Puffed Rice. The new confection." Unlike many items—such as Dr Pepper, which existed before the Fair—puffed rice made its world debut at the event.

Photograph by the Official Photographic Company
N20605

Souvenir watch fob advertising Dr Pepper, 1904

This fob was likely produced by the Dr Pepper Company as a marketing tool to promote its drink at the Fair. Dr Pepper had been advertised as a cola made with 23 different flavors, and the fob suggests that the display won a silver medal. Before 1904, Dr Pepper was only a regional drink from Waco, Texas, but it was such a hit at the Fair that it soon became popular nationwide.

Gift of Ken and Denise Freund
1984-004-0001

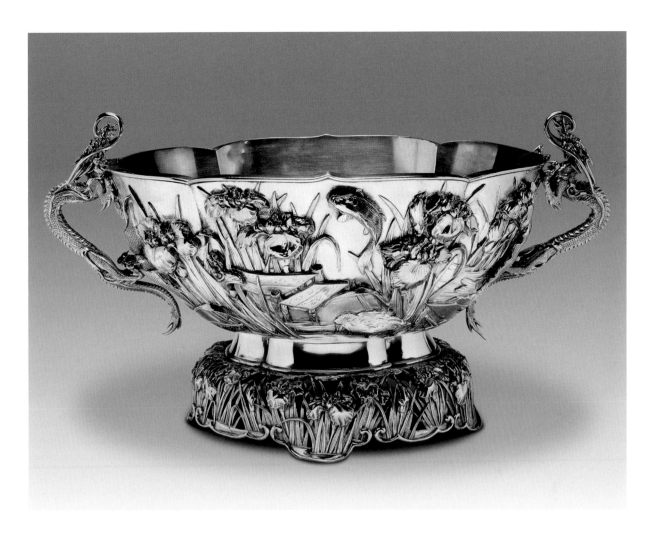

Punch bowl presented to David R. Francis, 1904

The Japanese delegation presented this silver punch bowl to World's Fair president David R. Francis on the last day of the Fair—also known as Francis Day. The bowl symbolized the cross-cultural interchange between the East and the West. Manufactured in Japan by Japanese craftsmen who were overseen by representatives from St. Louis–based Mermod & Jaccard, the bowl is in a shape common to Europe and the United States, but its decoration bears Asian symbols. Dragons, which symbolized wisdom and fertility, adorned many of the Asian pavilions at the Fair.

Gift of Anne Francis Currier
1979-075-0001

Field of stumps in Forest Park with the Administration Building in distance, 1902

Forest Park was aptly named: This image shows just some of the vast number of trees that were cleared away so that construction work could begin on the fairgrounds. River des Peres—buried so that more land could be developed—is also visible in this image.

Photograph by George Stark
N15485

Oak table presented to David R. Francis, 1901

This ornate oak table was made from the wood of one of the first trees cut down in Forest Park to make way for the 1904 World's Fair grounds. George Parker of the St. Louis Furniture Board of Trade presented the desk to David R. Francis, and it was used by the Fair organizers during their preparations. Also visible are the president's gavel, made from wood of the same tree, and the hand-embossing press used by the Louisiana Purchase Exposition Company.

Table made by the Western Furniture Company
Gift of George T. Parker
1928-007-0001

Embossing press, ca. 1901
X11303

Gavel presented to David R. Francis, 1901

1961-053-0001

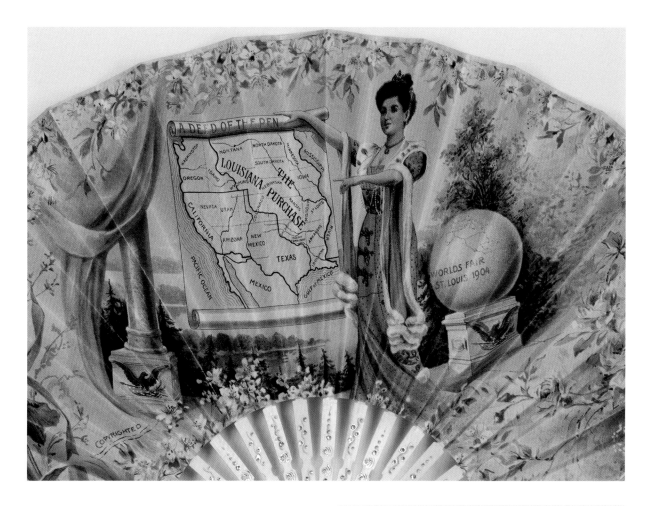

Souvenir folding fan, 1904

Handheld folding fans were among the most practical World's
Fair souvenirs. The event ran from April 30 to December 1, so it
spanned the hot St. Louis summer. While many of the souvenirs
had images of the beautiful palaces, this one also tells a bit
of history. The 1904 World's Fair, also known as the Louisiana
Purchase Exposition, commemorated the 100th anniversary of
the Louisiana Purchase. The fan depicts the huge swath of land
that Napoleon signed over to the United States, comprising
much of what is the Midwest today. Marguerite Kehlor Tower, the
donor's mother, was 18 when she presumably attended the Fair
and purchased the fan.

Gift of George T. and Eugene Pettus Jr.
1972-019-0006

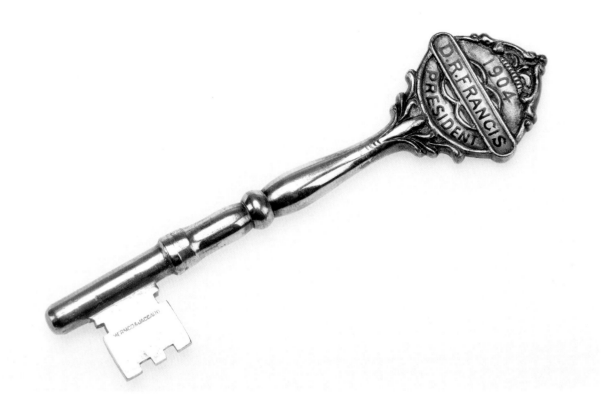

Gold key presented to David R. Francis, 1904

This key, donated to the Missouri Historical Society by the Louisiana Purchase Historical Association, was presented to World's Fair president David R. Francis, who used it to symbolically open the Fair. When the Fair ended on December 1, 1904, the committees' work turned to preservation. A historical association was formed, which maintained the photos and records of the Louisiana Purchase Exposition Company until 1926, when it disbanded and offered all of its materials to the Missouri Historical Society. MHS received an extensive archive of company records, official photographs, and numerous objects, many of which belonged to David R. Francis.

Gift of Louisiana Purchase Historical Association
1926-053-0037

Louisiana Purchase Exposition stock certificate, 1903

The 1904 World's Fair cost $15 million to stage. Of that amount, $5 million came from the federal government, $5 million came from the state and city governments, and $5 million came from individual and corporate stockholders. Stock purchasers received certificates that noted how many stocks they had bought. Each stock was valued at $10. Many buyers purchased the stock with no expectation that the Fair would make money but rather to help fund the exposition. This is one of two shares 25-year-old Edward Alt bought on October 19, 1903.

A0934-00115

Bissell "Parlor Queen" World's Fair gold medal model, ca. 1904

The latest technology at the World's Fair wasn't just about communication and industrial machines. It was also about housecleaning. The Bissell Company displayed this model floor sweeper, called the "Parlor Queen," promising that it would make cleaning easier and would last longer than conventional brooms. Bissell was awarded a gold medal at the Fair, which it used to further promote the Parlor Queen.

Made by Bissell Company
Provided by the Pieber Family Donor Advised Fund at the Greater Saint Louis Community Foundation
2009-052-1133

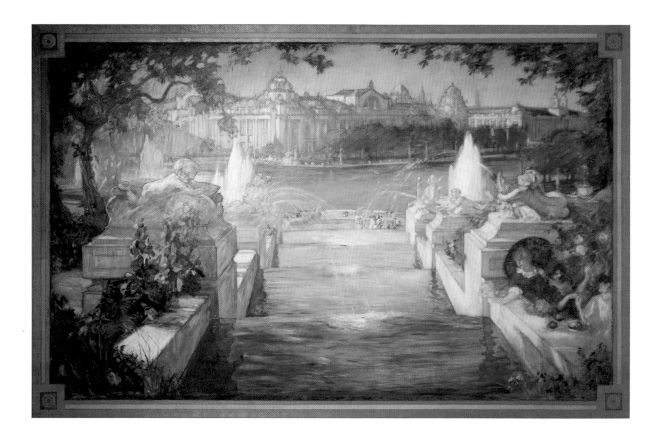

Cascades and Grand Basin at 1904 World's Fair, 1914

The Louisiana Purchase Exposition Company commissioned Fred Green Carpenter to paint a World's Fair–themed mural in the newly constructed Jefferson Memorial Building. Carpenter studied at the St. Louis School of Fine Arts and the Académie Julian in Paris. He also worked as a guide at the Palace of Fine Arts, a job that possibly inspired the view he depicted in this painting. Today visitors to the *1904 World's Fair* gallery at the Missouri History Museum can see the mural up on the gallery's west balcony wall, to the left of Frederick Gray's mural of Festival Hall and the Cascades.

Oil on wall by Fred Green Carpenter
1914-085-0001

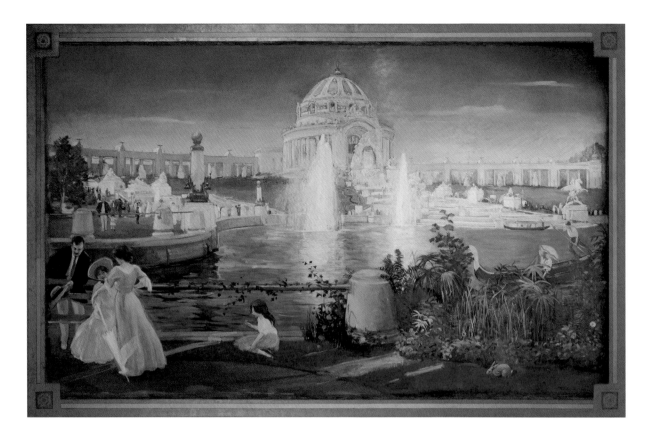

Festival Hall and Cascades at 1904 World's Fair, 1914

Frederick Gladstone Gray was also commissioned by the Louisiana Purchase Exposition Company to paint a mural in the Jefferson Memorial Building. Like Fred Green Carpenter, Gray studied at the St. Louis School of Fine Arts and the Académie Julian in Paris. His painting shows Festival Hall and the Cascades. This mural is also located inside the *1904 World's Fair* gallery, up on the balcony's west wall, to the right of Fred Carpenter's mural of the Cascades and Grand Basin.

Oil on wall by Frederick Gladstone Gray
1914-085-0002

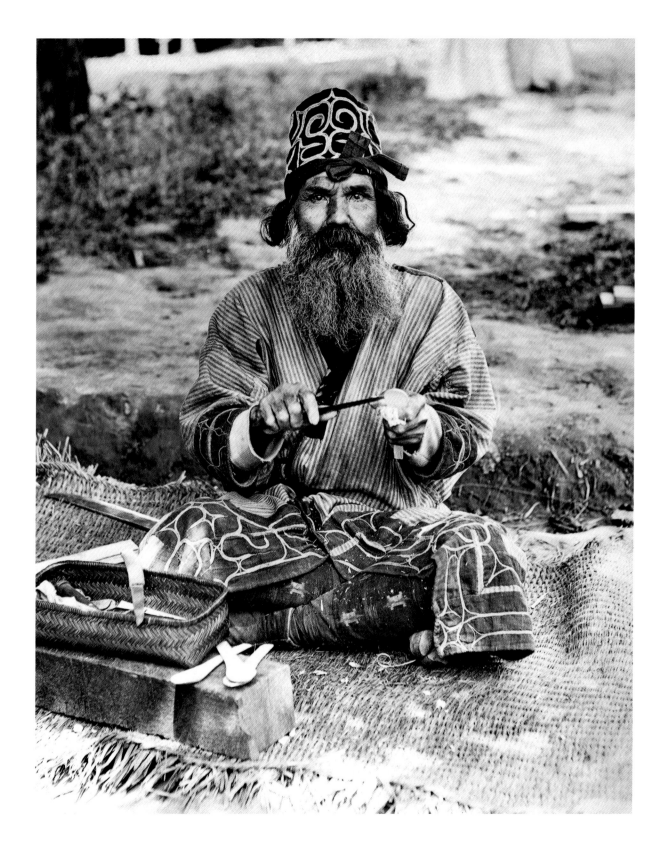

Ainu artisan in the Department of Anthropology, 1904

People from many different nations resided within the Department of Anthropology, often living in dwellings they built themselves to resemble homes native to their country. Inside these villages, they were asked to go about their daily lives while fairgoers looked on. Some people spent their days making souvenirs. This man—an Ainu, indigenous to Japan's northern islands—is carving a wooden spoon.

———
N20144

Spoon carved by an Ainu artisan, 1904

This wooden spoon was carved by an Ainu person who lived in the Department of Anthropology, located on the fairgrounds' far western edge.

———
X08493

American Indians practicing archery for Anthropology Days, 1904

The Fair's Anthropology Days pitted "savages" against one another in a range of competitions, from dancing to pole climbing, as well as more traditional Olympic events, such as archery and running. However, many of the participants were unfamiliar with the events they were forced to compete in, which satisfied the organizers' intent: to prove white superiority in sports.

Photograph by Jessie Tarbox Beals
N20667

Anthropology Days tug-of-war match, 1904

The Milwaukee Athletic Club competed against the South African Boers in a tug-of-war match during Anthropology Days.

Photograph attributed to Jessie Tarbox Beals
N20195

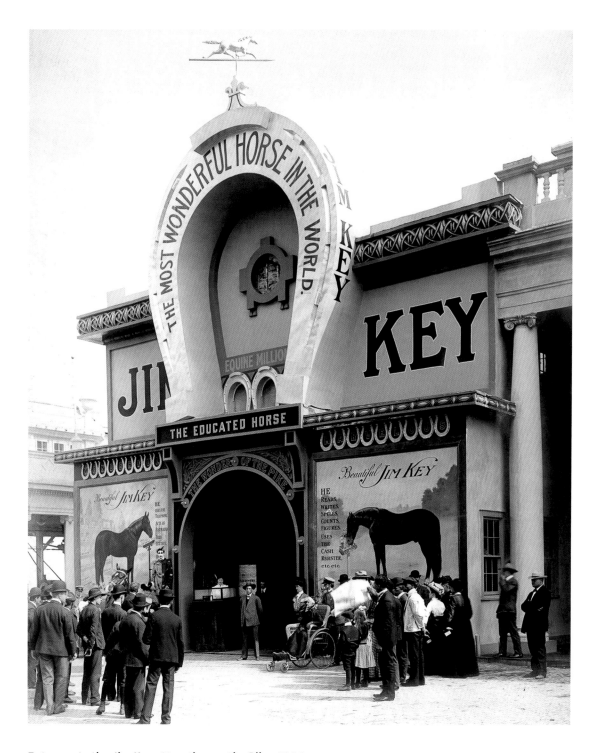

Entrance to the Jim Key attraction on the Pike, 1904

Photograph by Official Photographic Company

N27941

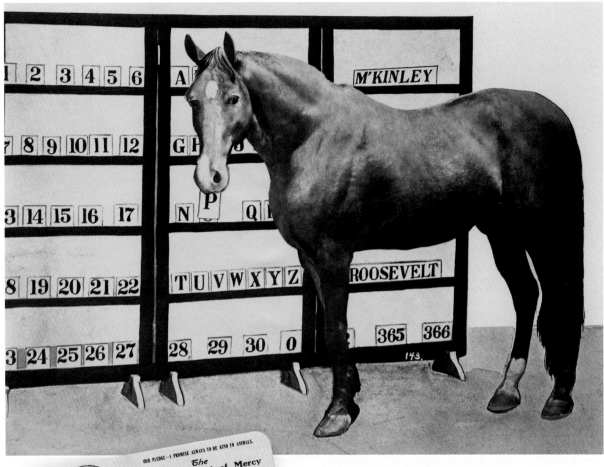

"Jim Key, the Educated Horse," 1904

"Jim Key, the Educated Horse" was one of the Pike's most popular attractions. Owned by Albert Rogers, Jim Key, a mixed-breed Arabian Hambletonian, could spell, do math, sort mail, make change with a cash register, tell time, and identify flags.

Photograph by Official Photographic Company
N28448

Jim Key Band of Mercy honorary membership card, 1904

Cards like this one were given to members of the Jim Key Band of Mercy, a youth organization that promoted being kind to animals. At every meeting the members recited this pledge: "I will try to be kind to all living creatures and try to protect them from cruel usage."

A0934-00417

Roller chair used at the World's Fair, 1904

There were many ways to get around the fairgrounds, including by roller chair. Visitors could rent them for 60 cents an hour. For $1.25 an hour—more than double the cost of admission to the Fair itself—visitors could hire a guide, who would push the chair for them and point out all the interesting things there were to see and do. The guides, often college men, were paid 18 cents an hour.

Gift of Morton and Jane Levy
2004-145-0001

Lawn dress, ca. 1904

For some, a trip to the Fair was about being seen. Wanting to look fashionable and have their picture taken, many women wore stylish dresses, such as this lavender-print lawn dress worn by Elizabeth Barrow Huntington. She was 38 years old when she attended the Fair.

Gift of Nell Cooper Huntington
1977-123-0001

Proclamation inviting all nations to the St. Louis World's Fair, 1901

I do hereby invite all the nations of the earth to take part in the commemoration of the Purchase of the Louisiana Territory, an event of great interest to the United States and of abiding effect on their development, by appointing representatives and sending such exhibits to the Louisiana Purchase Exposition as will most fitly and fully illustrate their resources, their industries and their progress in civilization. . . .

In 1901, President William McKinley issued a call for all nations to participate in the Louisiana Purchase Exposition, an event he hoped would draw more countries than any other World's Fair before it. The proclamation states that the Fair would take place in 1903, the 100th anniversary of the Louisiana Purchase. But convincing so many nations to come to St. Louis took longer than expected, as did construction of the fairgrounds, so the Fair was pushed back to 1904. Pictured alongside McKinley on the proclamation is Theodore Roosevelt, who became president after McKinley was assassinated in 1901. President Thomas Jefferson and French emperor Napoleon Bonaparte are included for their roles in the Louisiana Purchase. Secretary of State John Hay and president of the Louisiana Purchase Exposition David R. Francis are also pictured.

N16220

Couch from Abraham Lincoln's railroad car, 1865

This couch and two matching chairs furnished the presidential railroad car built for Abraham Lincoln, who was invited to take it for a trial run on April 15, 1865. But after Lincoln's assassination on April 14, the car became part of a funeral train. Lincoln's family used the parlor car as they traveled back to Illinois with his body. Eventually the furnished car was exhibited in the Lincoln Museum at the 1904 World's Fair. The train car burned in 1911, but the couch and three chairs survived. The president of the St. Louis Car Company purchased the pieces and donated them to the Missouri Historical Society.

Gift of Edmond C. Donk
1958-062-0001

Souvenir card from Dedication Day ceremonies, 1903

Just as St. Louisans wanted keepsakes from the 1904 World's Fair, they also wanted mementos from the Dedication Day celebration that took place the year before. This souvenir card belonged to 16-year-old Adele Quinette, who wrote in her scrapbook that she had a great view of both President Roosevelt and David R. Francis, noting that it was "the best military parade I have ever seen."

Gift of Mr. and Mrs. Stephen P. Phelps
A3135-00134

Souvenir spoon with locket featuring an image of David R. Francis, 1904

According to the donor, this silver locket spoon was presented to Thomas D. Teasdale at a special dinner for sponsors of the 1904 St. Louis World's Fair.

Gift of Beatrice Davidow Newman Mack
1974-028-0001

Ceramic tumbler with black transfer image of the Pylonic Gateway, 1903

Ceramic souvenirs from the Fair came in many shapes and sizes. They often included a black-and-white transfer image of one of the ornate palaces or other significant buildings on the fairgrounds or in the city. This tumbler has an image of the Pylonic Gateway, a structure that was proposed to serve as a grand entrance that opened to the main view of the fairgrounds. It was never built, making this an especially sought-after souvenir.

Provided by the Pieber Family Donor Advised Fund at the Greater Saint Louis Community Foundation
2009-052-1586

Tyrolean Alps ceramic souvenir dish, 1904

The Pike's Tyrolean Alps was a sprawling 9-acre attraction modeled after the Bavarian Alps. It consisted of 21 buildings, a mountain made of staff, and a tram that took visitors to the top. It also included a 2,500-seat German restaurant co-run by Tony Faust, a well-regarded St. Louis restaurateur.

Gift of Marian and Ethel Herr
1995-073-0002

Elephants on a waterslide, 1904

Elephants were forced to "shoot the chutes"—slide down a waterslide—at Hagenbeck's Zoological Paradise and Animal Circus on the Pike, one of the Fair's most popular attractions. It cost 25 cents for visitors to enter.

Photograph by Official Photographic Company
N20738

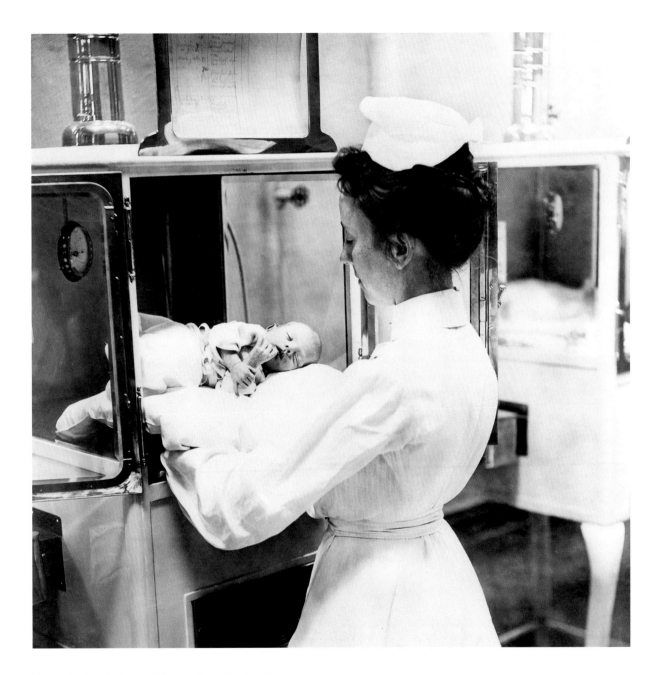

The baby incubator exhibit on the Pike, 1904

Although the incubator exhibit was intended to showcase scientific advancements in caring for premature babies, it was initially run by a doctor who had little experience. Fed a poor diet and languishing in overheated machines, these infants were stricken with vomiting and diarrhea, and the outcome was tragic: Reportedly, 39 of the 43 babies on display in the incubators died. One doctor called it "the crime of the decade." Nonetheless, the exhibit turned a profit and continued to operate. Visitors could walk through for 25 cents.

Photograph by Jessie Tarbox Beals
N16594

"Finger Print System of Identification" card, ca. 1904

Nations such as Ireland, Great Britain, and India were already using fingerprint identification, but the method wasn't adopted in the United States until 1902. The Palace of Education at the 1904 World's Fair introduced the technology to many Americans.

Unknown photographer
N28177

Missouri State Building ablaze, 1904

When a hot-water heater exploded in the basement of the Missouri State Building on November 10, 1904—just 10 days before the Fair would close—a raging fire ensued. Fire engines and crews from 15 companies were dispatched to find the structure completely engulfed in flames. While the building was a total loss, much of the furniture and the books from the model library were saved.

———

N44489

Silver fireman's badge, 1904

The Louisiana Purchase Exposition Fire Department had a massive responsibility. Most of the buildings were rife with potential fire hazards: They were hastily built, constructed of wood frames, and had ornate temporary façades. Several units of the St. Louis Fire Department also served the fairgrounds.

Gift of Charles J. Bartley
1954-040-0001

Drop-front writing desk of Ulysses S. Grant, ca. 1850

Ulysses S. Grant used this writing desk in St. Louis prior to the Civil War. At the World's Fair, it was displayed in a cabin he had built, known as "Hardscrabble." The cabin made its way to the World's Fair as part of a marketing gimmick by C. F. Blanke, who used the cabin's image to market his coffee and tea to fairgoers. Hardscrabble was later disassembled and rebuilt at its present location in Grant's Farm by brewery magnate August A. Busch.

Gift of Mary Koenig Benecke
1908-022-0001

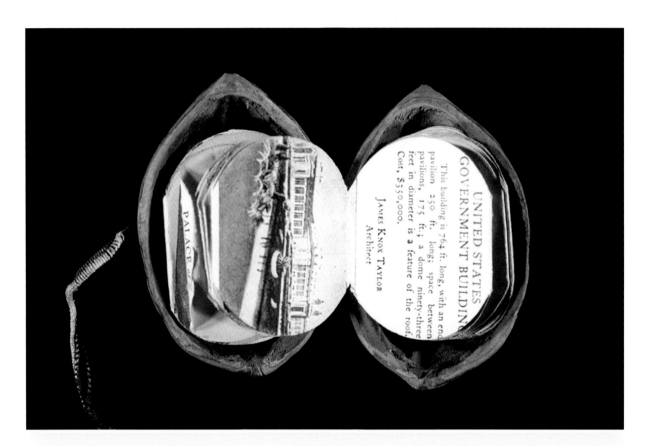

World's Fair in a nutshell, 1904

Made by Nutshell Novelty Company, this was one of the most popular souvenirs at the Fair. It featured an accordion-style collection of pages with halftone photos and descriptions of 44 prominent buildings on the fairgrounds, all encased in a walnut shell.

Made by Nutshell Novelty Company
X00553

Official flag of the Louisiana Purchase Exposition, 1904

The Louisiana Purchase Exposition commemorated the land deal with France that nearly doubled the size of the United States. The fleur-de-lis represents France. The 14 stars signify the states that were carved out of the Louisiana Purchase, and the flag's four colors represent France, the United States, and Spain—countries that had each ruled over the territory.

Gift of Elizabeth M. MacMillan
1990-059-0001

Index

Index

Index

Index